Mute Poetry, *Speaking Pictures*

Essays in the **Arts**

Mute Poetry, Speaking Pictures

Leonard Barkan

PRINCETON UNIVERSITY PRESS

Princeton and Oxford

Copyright © 2013 by Princeton University Press
Published by Princeton University Press, 41 William Street,
Princeton, New Jersey 08540
In the United Kingdom: Princeton University Press, 6 Oxford Street,
Woodstock, Oxfordshire OX20 1TW

press.princeton.edu

Library of Congress Cataloging-in-Publication Data
Barkan, Leonard.
 Mute poetry, speaking pictures / Leonard Barkan.
 p. cm. – (Essays in the arts)
 Includes bibliographical references and index.
 ISBN 978-0-691-14183-1 (alk. paper)
 1. Art and literature. 2. Visual communication. 3. Written communication.
I. Title.
 PN53.B38 2013
 700.1–dc23 2012019508

British Library Cataloging-in-Publication Data is available

This book has been composed in Garamond Premier Pro with Myriad Pro
Printed on acid-free paper. ∞
Printed in the United States of America
10 9 8 7 6 5 4 3 2 1

It is not the disciplines which need to be exchanged, it is the objects: there is no question of "applying" linguistics to the picture, injecting a little semiology into art history; there is a question of eliminating the distance (the censorship) institutionally separating picture and text. Something is being born, something which will invalidate "literature" as much as "painting" (and their metalinguistic correlates, "criticism" and "aesthetics"), substituting for these old cultural divinities a generalized "ergography," the text as work, the work as text.

—Roland Barthes, "Is Painting a Language?"

Contents

Acknowledgments

Art, they say, is long and life short. But a volume like this one, whose concerns the author has nourished over many years even though he is presenting them here in relatively few pages, may turn that cliché on its head: something like *vita longa, libellus brevis.* The long life that gave its origins to this book was lived above all in the classroom. I would not have been able to do the reading and thinking that is reflected in these pages if I hadn't spent so many years in the marvelously demanding job of instructing undergraduates and graduates, of engaging in the reciprocal act of keeping up with them and getting them to keep up with me. So, in place of the traditional salutations to my mentors and colleagues, I acknowledge here four decades of students—my *other* mentors and colleagues. More than acknowledging, I dedicate this volume to the remarkable men and women whom I have taught at the University of California, San Diego (1971–74), Northwestern University (1974–90), Washington University in St. Louis (1990), the University

of Michigan (1990–94), New York University (1994–2001), Princeton University (2001 and counting), the Freie Universität Berlin (2010) and the Johns Hopkins University (2011).

In a similarly retrospective vein, it should be mentioned that earlier versions of some of the material in this book appeared in *Renaissance Quarterly*, in *Antiquity and its Interpreters*, edited by A. Payne, A. Kuttner, and R. Smick and published by Cambridge University Press, and in *The Forms of Renaissance Thought: New Essays in Literature and Culture*, edited by L. Barkan, B. Cormack, and S. Keilen and published by Palgrave Macmillan.

Introduction

A few signposts with which to begin our journey:

> Where can we find a more violent or elaborate attitude
> than that of the *Discobolus* of Myron? Yet the critic who
> disapproved of the figure because it was not upright,
> would merely show his utter failure to understand the
> sculptor's art, in which the very novelty and difficulty
> of execution is what most deserves our praise. A similar
> impression of grace and charm is produced by rhetori-
> cal figures, whether they be figures of thought or figures
> of speech. For they involve a certain departure from the
> straight line and have the merit of variation from the
> ordinary usage.
>
> —Quintilian, *Institutio Oratoria*, 2.13.8–10

[The story of Alexander and Roxana] is expressed so
well [by Raphael] that one would be doubtful whether
Raphael took it from Lucian's books or Lucian from Ra-

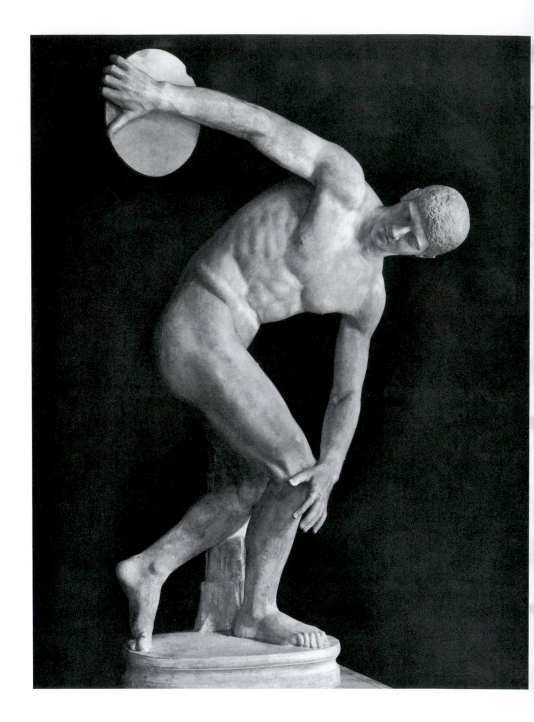

phael's paintings, were it not that Lucian was born some centuries earlier. But who cares?

—Lodovico Dolce, *Aretino*

"I'll wager," said Sancho, "that before long there won't be a tavern, an inn, a hostelry, or a barbershop where the history of our deeds isn't painted. But I'd like it done by the hands of a painter better than the one who did these [of the Trojan war, on the wall of an inn in La Mancha].

"You are right, Sancho," said Don Quixote, "because this painter is like Orbaneja, a painter in Ùbeda, who, when asked what he was painting, would respond: 'Whatever comes out.' And if he happened to be painting a rooster, he would write beneath it: 'This is a rooster,' so that no one would think it was a fox. And that, it seems to me, Sancho, is how the painter or writer—for it amounts to the same thing—must be who brought out the history of this new Don Quixote: he painted or wrote whatever came out."

—Cervantes, *Don Quixote*, part 2, chapter 71

Myron, *Discobolus*. Museo Nazionale Romano, Rome. (Alinari/Art Resource, NY.)

The incapacity of dreams to express [logical relations] must lie in the nature of the psychical material out of which dreams are made. The plastic arts of painting and sculpture labour, indeed, under a similar limitation as compared with poetry, which can make use of speech. . . . Before painting became acquainted with the laws of expression by which it is governed, it made attempts to get over this handicap. In ancient paintings small labels were hung from the mouths of the persons represented, containing in written characters the speeches which the artist despaired of representing pictorially. . . . But just as the art of painting eventually

found a way of expressing, by means other than the floating labels, at least the *intention* of the words of the personages represented—affection, threats, warnings, and so on—so too there is a possible means by which dreams can take account of some of the logical relations between their dream-thoughts.

—Freud, *The Interpretation of Dreams*, 4:312–14

In every one of these cases—and thousands of others besides—a writer summons up an artist, a text cannot explain itself without a picture, language momentarily cedes authority to image. Why should the exaggerated arc of the disk-thrower's sculpted body, a property of seemingly pure visuality, be invoked to provide justification for practices of speech? What is at stake in fantasizing that the relation between a second-century writer and a sixteenth-century painter could defy the order of time itself and be freely reciprocal? How is it that the idea of spontaneous composition by accident, should seem plausible (if hardly praiseworthy) in the execution of a painting but turn into an accusation of the worst sort of amateurism when applied to literary narrative? And what precisely is the pay-off when Freud characterizes dreams as visual artifacts (the equation is more explicit in *On Dreams*: "the manifest content of dreams consists for the most part in pictorial situations" [5:659]) and thus casts his own analytic activity as, essentially, fitting texts to images? And, to reference a fifth quotation (this from Anon.), why exactly should one picture be worth a thousand times more than one word?

The reader may look in vain for explicit answers to these questions in the pages that follow, precisely because it is the indeterminate nature of the underlying relationship across the different media of expression that is the real subject of this book. All the above quotations repose atop some sort of syllo-

gistic reasoning—if *x* is true of pictures, it follows that *x*, or, as it turns out more likely, *x'* is true of text—but the moment one actually asks *why* it follows, one realizes that one is embroiled in slippery argumentation rather than in the steel trap of logic. Word-and-image, in short, comes down to us not as a subject of rational inquiry or a reliable taxonomic grid so much as a particularly shifty trope. My notion here is to address the life of this figure—the term *figure* itself being a word-and-image metaphor—in a manner that is simultaneously rhetorical and historical, theoretical and aesthetic. For me, word-and-image is a crux, a shell game, an act of evasion, an attempt to promote one discourse at the expense of another, a particularly persistent skirmish in long-running wars for cultural prestige among different aesthetic and intellectual enterprises. At the same time, to put the matter more positively, word-and-image is an empowering device that has been used to enable makers of text and makers of pictures both to theorize and to practice their craft. It is my hope that the several viewpoints on this matter that appear in the following chapters, concentrating on, but not limited to, European culture from antiquity to the Renaissance, will illuminate these fundamental paradoxes without pretending to resolve them.

Visible and Invisible

S hortly before I turned sixteen, I took part in a high school film project. Each member of the group was required to write and direct a movie in the course of the summer, and we all served as each others' crew. My fellow-cineastes devoted laborious thought to the choice of a subject, only to end up with the sorts of themes—rock-and-roll, science fiction, the pangs of young love—that doubtless could have provided quite predictable maps of our various adolescent preoccupations. I, however, seized on some rather arcane material, and without a moment's hesitation. In German class, I had just been assigned a Stefan Zweig short story called "Die unsichtbare Sammlung," and I decided it was perfect for a movie.

It was the story of an impoverished elderly couple—the husband was already totally blind—whose only remaining treasure was his collection of old master prints. A shrewd art merchant, on the lookout for some valuable goods at a low price, journeys to the couple's remote abode in the provinces. The old man is thrilled at the prospect of showing off his

treasures, but once the wife understands the purpose of the visit, she gets desperately upset, begs the visitor to return to his hotel, and sends her daughter there to provide him with an explanation. It seems that in order to have the money to live during a time of grave economic crisis, the two women have been selling off the collection one piece at a time. By now there is nothing left but the blank sheets of paper that they have been regularly inserting into the precious folios. The blind old man cannot tell the difference, but now that an expert from the city has come calling, their cover is about to be blown. Not only is the crafty dealer deprived of his expected fast profit, but, pressured by mother and daughter, he finds himself back in the apartment, where he is compelled to sit for hours with the old man and his imaginary art objects. At first unwillingly and then with increasing empathy and imagination—this character change is really the point of the story—he goes through the charade of looking at nonexistent Dürers and Mantegnas and Rembrandts while the blind collector basks in the delusory pleasures of believing that he owns several hundred priceless masterpieces.

I gave no particular thought, so many decades ago, to the reasons why this subject, with all its dim resonances of *Mittel-Europa* and the German inflation of the 1920s, should have seized my imagination in preference to stuff I actually knew from my own experience. From my present perspective, however, I am first of all struck by what seems like the bizarre determinism of the episode: some decades before I had ever heard the word *ekphrasis*, I was making a movie about it. I knew nothing about classical rhetoric, and certainly had never heard the technical term for the verbal presentation of a visual object inside a literary work; but it was clearly the question of words-about-pictures that led me to seize on the Zweig material. The exposition in my movie (as, frankly, in the story it-

self) was a bit ponderous; it wasn't easy for me to establish on screen what kind of character the art dealer was, why he was scouring the provinces for merchandise, and how it happened that the old couple could be living in such straitened circumstances and yet be presumably in possession of such an artistic treasure trove. Where the film at last picked up its little bit of speed, however, was the big final scene—to which I allotted more than half of the total screen time—when the blind old man, in possession of a captive audience, lovingly described sheet after sheet of his invisible collection. The camera relentlessly took in the shiny emptiness of page after page while the elderly collector recounted a lifetime's familiarity with each art work. Only now, when I reread the original text, do I realize that I invented most of these speeches. The lengthy monologues recounting the features of Dürer's *Great Horse* or Rembrandt's *Hundred Guilder Print*—which I recall with some agony, since the actor who played the old man had a lot of trouble retaining his lines—have no place in the original story at all; we hear *about* these speeches, but we never actually hear them. Zweig was clearly less interested in ekphrasis than I was.

I got hooked on "The Invisible Collection" because I believed that the most cinematic thing of all (which is usually taken to mean the most *visual* thing of all) would be the recurring shot of an empty page. Actually, there is more to it than that. This was my second summer in the film project. The first year we had made only silent films, since recording equipment was too expensive and too complicated for us to learn about; only now were we working in sound. And even with this leap forward, our audio equipment wasn't quite up to the rigors of perfect lip synchronization; hence it was much easier for us to work in voiceover than in dialogue. The real allure, both technological and aesthetic, of the Zweig short story was thus the potent incongruity of the blank sheet on the screen and

the florid voice on the soundtrack. I didn't know it at the time, but I had chosen a narrative which—like so many others, as it turned out—*seemed* to set words and pictures in parallel but in truth exposed a vast gap between them.

That unfulfilled promise of parallelism is really the theme of this book. Like Zweig's old collector (though I hope my sheets offer a little more substance), I come to this endeavor with a gallery full of images and texts stored in my memory. We will come soon enough to such far-ranging and influential pronouncements as *ut pictura poesis* or *a picture is a silent poem, a poem is a speaking picture*, which have led to grandiose imaginative leaps whereby sonnets and cupolas, or tragedies and friezes, have been placed in a common comparative space that their creators could scarcely have anticipated. For the moment, we may consider the simplest case of all: what happens when a work of visual art comes with a verbal caption? To the modern museumgoer, after all, this is the defining condition of images that are worthy of being housed in hallowed spaces: hence, every visit to the Louvre or the Metropolitan is inevitably an exercise in word-and-image.

If it seems that that way madness lies—if, in other words, we shy away from analyzing the optical and interpretive patterns of every museum visitor as he or she measures the relative weight of the object inside the frame and the placard located (usually) to its right—it might be best to begin with the cases where the picture houses something like a caption within itself. Take the reclining nude painted by Jean Cousin the Elder around 1550 (figure 1.1). The artist has clearly absorbed various classical and Italian visual conventions, including a certain traditionally erotic display of the female body, the presence of signifying props like the skull or the ewers, and the surrounding landscape that, depending on who is looking at it, may hover between mere scene-painting and deliberate

message-making. Such interpretive questions are, at least partially, laid to rest, however, because the artist has inscribed the words EVA PRIMA PANDORA ("Eve first Pandora") in a prominent spot on the canvas.

We could imagine this inscription to be a conveniently authoritative sixteenth-century equivalent to a museum wall caption, which informs viewers what is being depicted and, to some extent, what they should think about it. For me, though, this textual cartouche raises as many questions as it answers. Are we, for instance, to locate it literally in the space of the picture, hanging over the lady's outstretched frame? For the purposes of emblem or allegory, such an implication is almost absurd, since it is the categorical separation of signifier from signified, as much as their hermeneutic interconnection, which defines such systems. Yet in Cousin's painting—perhaps because it *is* a painting and not an allegorical poem or a page out of an emblem book—such spatial literalism seems plausi-

1.1

Jean Cousin,
Eva prima Pandora
(1550). Louvre, Paris.
(Réunion des Musées
Nationaux/Art
Resource, NY.)

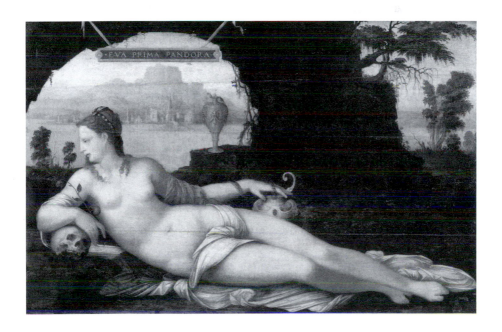

ble, given the perspectival composition of the whole scene and the two golden ribbons which begin to suggest that the little sign is actually attached to the tree, even though the point of connection, perhaps coyly on purpose, falls outside the picture plane. Yet more unsettling is the content of the inscribed caption. Rather than performing the practical service of telling us what we are looking at (as on the typical museum wall), these words precisely confuse the issue. Are we looking at Eve, or are we looking at Pandora? The rules of pictures would seem to insist on one or the other; after all, it's precisely the element of multiple time planes, captured in that pivotal PRIMA, which is generally thought to be inexpressible in the visual medium, and therefore the province of words.

1.2

Nicolas Poussin,

Arcadian Shepherds

(1637). Louvre, Paris.

(Erich Lessing/Art

Resource, NY.)

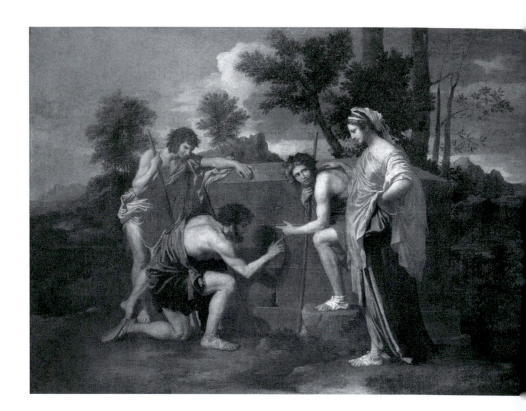

6

At least, Eve/Pandora doesn't seem to *know* that she has an allegorical sign hanging over her head. Elsewhere, however, text becomes part of the story, generally because someone is either writing words or reading them. Two very famous seventeenth-century paintings immediately spring to mind. Both Poussin's *Arcadian Shepherds* (figure 1.2) and Rembrandt's *Belshazzar's Feast* (figure 1.3) center on pieces of writing. Not only is each of these texts, to varying degrees, in an arcane language, but in both instances the entire plot of the story revolves around the challenging toil of decoding the mysterious meaning of the words. Between Rembrandt and Poussin the process works differently. In the case of *mene mene tekel upharsin*, the hermeneutic labor has already been narrativized and completed

1.3

Rembrandt, *Belshazzar's Feast* (1635). National Gallery, London. (National Gallery, London/Art Resource NY.)

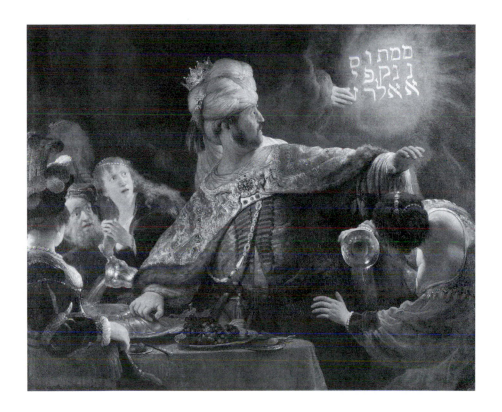

inside the biblical tale, with Daniel unpacking the handwriting on the wall as signifying the end of Belshazzar's reign; in short, the viewer's work has already been done, though it exists only in future prospect at the moment of the picture. By contrast, *Et in Arcadia ego* is placed at the center of a scene in which the interpretive effort is currently under way; and, since no very clear direction is offered by the individuals performing this labor, the Daniel-like work is left decidedly for the viewer to undertake, as generations of great art historical literature have demonstrated. So far as my own personal gallery is concerned, however, these celebratedly enigmatic canvases are, paradoxically, rather straightforward entries by visual artists in the realm of language, in essence postulating a relatively simple relationship between the verbal and the visual. *Picture*, according to this model is real, substantive, mimetic, objective, earthbound, while *word* is divine, revelatory, in a foreign tongue, and mightily in need of expert interpretation, even among those who speak its arcane language.

My own interest is more engaged when the opposition seems less thoroughly staged. To cite yet another famous seventeenth-century work, many explanations have been offered as to what went wrong when Caravaggio produced a St. Matthew who was closely engaged with the angel in composing the words of his gospel (figures 1.4, 1.5). Whatever the theological and/or corporeal issues may have been, the replacement picture (the only one we still possess, unfortunately) radically demotes the book, the authentic Hebrew with which it is being inscribed, and the material process of inscription. Whereas the earlier picture centers on a focal point where textuality and physicality—letters and hands—coincide, the second version removes the Evangelist's pen from the (now largely invisible) book and transfers the act of composition not just from an earthly to a heavenly personage but from an activity involving

language to something far more abstracted, and painterly, as constituted by the mysterious and yet oddly precise gesture of the angel's fingers. The contrast to *Belshazzar's Feast* seems notable: if the *Matthew* as we now see it in San Luigi dei Francesi represents a more orthodox mentality than did its predecessor, might part of that retrenchment consist of a decision to leave text—a Hebrew text, yet—out of the picture?

Text, of course, can *never* be left out of the picture, or at the very least not within the universe of representational, narrative, and iconological art during the premodern eras that form the basis of my own scholarly experience. Words actually

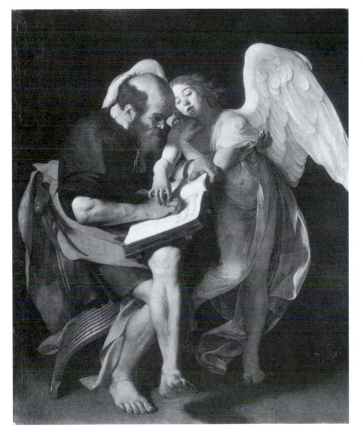

1.4
Caravaggio,
Matthew and the Angel
(1602). Formerly in
Staatliche Museen,
Berlin (destroyed).
(Bildarchiv Preus-
sischer Kulturbesitz,
Berlin/Art Resource
NY.)

painted on canvases may represent an overly literal sampling. Instead of *The Arcadian Shepherds*, perhaps we might take as our paradigm a different object in my personal picture gallery, the Donatello statue of the prophet Habbakuk (figure 1.6), known as *Lo Zuccone* (Big Head):

1.5

Caravaggio, *Matthew and the Angel* (1602). Contarini Chapel, S. Luigi dei Francesi, Rome. (Scala/Art Resource, NY.)

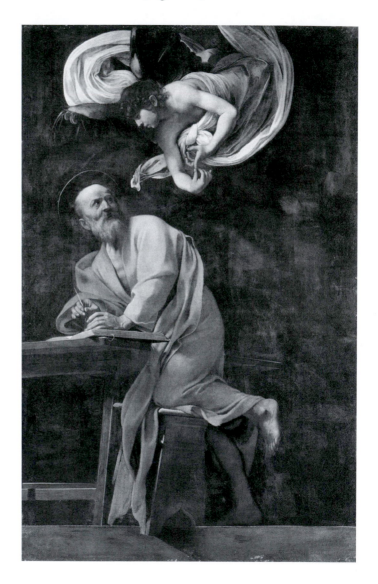

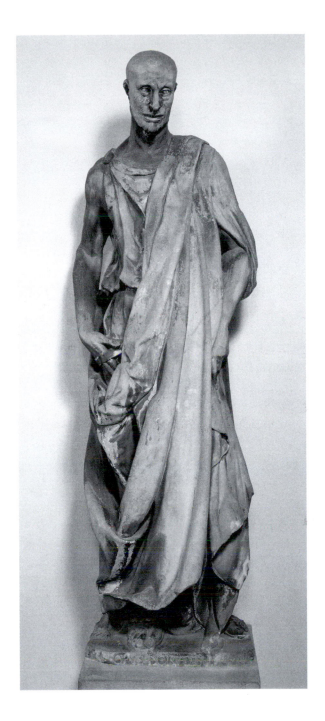

1.6
Donatello, *Habbakuk*
(*Lo Zuccone*)
(ca. 1430). Museo
dell'Opera del Duomo,
Florence. (Scala/Art
Resource, NY.)

[L]a quale per essere tenuta cosa rarissima e bella quanto nessuna che facesse mai, soleva Donato, quando voleva giurare, sí che si gli credesse, dire: "Alla fé ch'io porto al mio Zuccone", e mentre che lo lavorava, guardandolo tuttavia gli diceva: "Favella, favella, che ti venga il caca-sangue!" (Vasari, 2:405)

The latter was held to be a very rare work and the most beautiful that Donato ever made, and when he wished to take an oath that would commend belief he was wont to say, "By the faith that I place in my Zuccone"; and the while that he was working on it, he would keep gazing at it and saying, "Speak, speak, plague take thee, speak!" (De Vere, trans., 1:367)

Vasari's anecdotes are, as ever, richly revealing. The sculptor is imagined in the midst of intense creative process, and the sign of success is, or would be, the ability of the depicted figure to utter speech. In itself, this is the oldest of all articles of praise for art objects: they are so real that they almost seem to speak. But we must understand it as more than an offhand trope; not only does it testify to the language nexus in the visual representation of the human form, but it also introduces a central competitive/comparative element in this nexus. Every occasion when a (necessarily mute) human representation is celebrated for its speaking potential amounts to a reminder not only of the triumph achieved by the particular work under discussion but also of the devastating limitation under which all the visual arts operate. Hence, in the case of Vasari's Donatello, the furious, even profane struggle to produce the work, and the open-ended question of whether the statue can *favellare* or not, get signaled further by the proposition that the potential conversation will be taking place not between art object and viewer, as in the normal case, but between sculpt*or* and sculp-

tee. Hence, as well, the accompanying anecdote, in which (at least in the artist's opinion) the effort is so successful that the statue can operate as a certification of the maker himself, functioning as a sort of personal patron saint.

What would the *Zuccone* have to say if he *could* speak? Neither Donatello nor Vasari can tell us, which is not surprising, given that the statue depicts a fairly obscure personage and that it was produced as a one-off work rather than as part of a narrative ensemble that might summon up a known set of speech acts. Indeed, the very choice of *favellare*, which derives from *fabula*, serves to remind us of the burdens of iconography, that most fundamental system whereby text is implicated in picture: what does an artist have to do in order that an uncaptioned image succeed in telling its necessarily language-based story?

Another corner of my personal picture gallery reminds us that the term *story* itself has to be viewed broadly. In 1641, Rembrandt produced an etching in which he portrayed the Mennonite preacher Cornelis Claesz Anslo (figure 1.7) gazing off into a middle distance and seated at a table with large folio volumes; while his right hand holds a pen and supports a closed book, his left hand points toward some invisible spot in an open book. In response to this work—the anecdote is frequently rehearsed in the word-and-image literature—the poet Vondel composed an epigram:

Ay, Rembrandt maal Cornelis' stemm!
Het sichtbre deel is 't minst van hem:
't Onsichtbre kent men slechts door d'ooren;
Dic Anslo zien wil, moet hem hooren. (4:209)

Go ahead, Rembrandt, paint Cornelis's voice!
The visible part is the least of him:
The invisible can be recognized only through the ears;
Who wishes to see Anslo must hear him.

1.7

Rembrandt,
Cornelis Claesz Anslo,
Preacher (1641).
The Morgan Library
and Museum, NY.
(The Pierpont Morgan
Library, New York.
B.271, I. Photography:
David A. Loggio.)

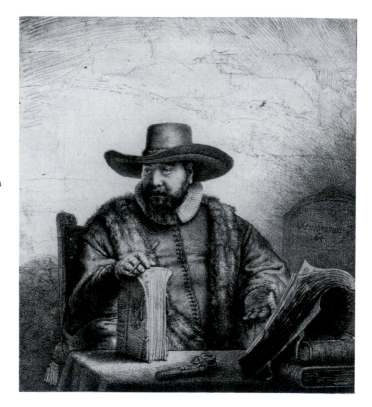

The language nexus here is not a story but rather a set of discursive materials that form at least as significant a problematic in the history of pictures and words: namely, rhetoric. Later in the present volume, I will consider the line of descent from Aristotle to Alberti arguing that the most successful pictures are understood to be those that *persuade*; and everywhere along this descendancy the relevant model for persuasion is the orator. To the extent that the visual arts wish to bask in this celebratory identification with rhetorically effective speech, it becomes a dangerous bargain: if it is difficult for a mute pictorial representation to convey the full outlines of, say, a biblical or Ovidian narrative, it is even more fantastical to conceive of such an image reverberating with the full

linguistic force of a Ciceronian oration. Anslo was a famous preacher, and Vondel uses that in a cunning strategy of undoing the specifically painterly privilege, unavailable to poets, of bringing persons into full sensuous life. This, in other words, is one person whose life cannot be represented by a mere visible likeness; the rendering of his excellences requires the aural medium over which painters are thought to have no purchase.

But in this case, Rembrandt seems to have sought the last word (or picture) by portraying Anslo again, this time in oil (figure 1.8). Clearly, the subsequent painting does make efforts to compensate by placing the subject in some sort of conversation: his mouth is more open, his hand gesture is more directly

1.8

Rembrandt,
Cornelis Claesz Anslo and His Wife (1641).
Gemäldegalerie,
Staatliche Museen,
Berlin. (Bildarchiv
Preussischer
Kulturbesitz, Berlin/
Art Resource, NY.)

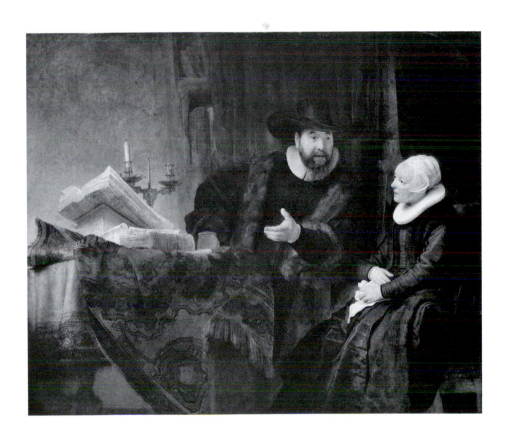

demonstrative, and he is joined by a lady (generally agreed to be his wife, a relative of Vondel, as it happens), who gives every evidence of paying rapt attention to that voice, which the pictorial medium cannot directly deliver. And it may even be that the de-emphasis on writing—pen, holder, and inkwell are all gone, and Anslo's hands are otherwise occupied—is meant to focus us toward voice. Yet these results seem to me rather equivocal. The diffusion of gesture and eye contact, the slight sense that the wife is in a different space from her husband, even the very fact that the audience of Anslo's celebrated rhetorical power is limited to the one individual who presumably gets to hear him talk all the time: such details leave me in some doubt as to whether the painting merely represents Rembrandt's dutiful effort at satisfying Vondel's objections.

There is, in fact, another change between the two pictures, not so often remarked upon, that may point to a different kind of Rembrandtian riposte. If *writing* has been demoted, *reading* may well be taking its place. The painting's composition signals a greatly increased role for the volumes now luminously arrayed on the worktable. If Vondel wishes to claim that this is a competition with one particular individual's body and his voice, Rembrandt seems to be moving toward an opposition with more enduring substance: between the authority of the Book and that of the preacher who expounds it. It may be that Anslo's unportrayable voice trumps the earlier etched portrait, but there is something that trumps them both, upon which Rembrandt lavishes some of his grandest visual effects. Which puts us in the same territory as Caravaggio: like his earlier contemporary, Rembrandt honors the book by keeping its linguistic contents invisible.

Invisible, as it turns out, is a key concept in more than one direction. Vondel's reference to *sichtbre* and *onsichtbre* summons up significant code words in Mennonite theology, according

to which the invisible church—variously identified with the individual's interior faith and with the collective company of the elect, as opposed to a more established and majoritarian form of worship—is to be understood as superior to anything that the senses might perceive. Following this line of thinking, Rembrandt's very medium, problematic throughout Protestantism, sentences his production to second-class status. But this sort of ideological framework ought not to seduce us into our own facile binaries. The deployment, just to take the current instance, of visible and invisible cannot be so simply mapped along the professional lines of painters and poets, as witness the fact that in the Anslo painting Rembrandt reserves some of his most powerful effects for the representation of the book.

The fact that the best card the painter has in his hand is really more text than picture will serve to remind us that, for all the presence of visual artists in this story, the whole matter of words and pictures is itself a textual, rather than a pictorial, subject. Indeed, if artists are glorifying the iconicity of books, it is even more common for writers to be appropriating the image. More than perhaps any other rhetorical move, this is the subject of the present work, but I will let one brief and (considering its author) comparatively straightforward instance stand for a whole class of instances:

C'est icy un livre de bonne foy, lecteur. . . . Je l'ay voüé à la commodité particuliere de mes parens et amis: à ce que m'ayans perdu (ce qu'ils ont à faire bien tost) ils y puissent retrouver aucuns traicts de mes conditions et humeurs, et que par ce moyen ils nourrissent plus entiere et plus vifve, la connoissance qu'ils ont eu de moy. Si c'eust esté pour rechercher la faveur du monde, je me fusse paré de beautez empruntees. Je veux qu'on m'y

voye en ma façon simple, naturelle et ordinaire, sans es-
tude et artifice: car c'est moy que je peins. Mes defauts
s'y liront au vif, mes imperfections et ma forme naïfve,
autant que la reverence publique me l'a permis. Que si
j'eusse esté parmy ces nations qu'on dit vivre encore souz
la douce liberté des premieres loix de nature, je t'asseure
que je m'y fusse tres-volontiers peint tout entier, Et tout
nud. Ainsi, Lecteur, je suis moy-mesme la matiere de
mon livre. (2)

This book was written in good faith, reader. . . . I have
dedicated it to the private convenience of my relatives
and friends, so that when they have lost me (as soon
they must), they may recover here some features of my
habits and temperament, and by this means keep the
knowledge they have had of me more complete and
alive. If I had written to seek the world's favor, I should
have bedecked myself better, and should present myself
in a studied posture. I want to be seen here in my simple,
natural, ordinary fashion, without straining or artifice:
for it is myself that I depict. My defects will here be read
to the life, and also my natural form, as far as respect for
the public has allowed. Had I been placed among those
nations which are said to live still in the sweet freedom
of nature's first laws, I assure you I should very gladly
have portrayed myself here entire and wholly naked.
Thus, reader, I am myself the matter of my book. (2)

Even before the verb *peindre* is introduced, the rhetoric of
Montaigne's "Avis au lecteur" is entirely based on metaphorics
long associated with pictorial portraiture. Portraits stand as
enduring memorials and substitutes for deceased loved ones;
they offer special authenticity, but they also run the risk of
being doctored up by flattery; and in the special case of *self-*

portraiture that is also *nude* self-portraiture, they promise a unique form of truth in a language that is universal—no need for subtitles when we are just looking at naked bodies—but that at the same time also conforms to the radically absolute communicative systems that get ascribed to primitives. Montaigne, in short, wishes he *were* a painter, or wishes to make us believe he wishes he were a painter, in the hopes of suggesting to us at the very outset of his project that the version of himself he is presenting in the succeeding pages possesses the very property that Vondel disparaged: visibility. It's a nice trick, and a necessary one for Montaigne, because it is difficult to imagine any self-portrait less attuned to picture and more attuned to words (for example, the huge networks of citation) than that which so voluminously follows these ten lines of introduction.

Just how logocentric this whole topic is will emerge via one final exhibit in my gallery, from another great producer of text:

> Here therefore [is] the first distemper of learning, when men study words and not matter. . . . How is it possible but this should have an operation to discredit learning, even with vulgar capacities, when they see learned men's works like the first letter of a patent or limited book, which though it hath large flourishes, yet it is but a letter? It seems to me that Pygmalion's frenzy is a good emblem or portraiture of this vanity; for words are but the images of matter, and except they have life of reason and invention, to fall in love with them is all one as to fall in love with a picture. (1.4)

Francis Bacon, here exploring his anxieties about the discursive humanism that he is himself practicing, does not have Montaigne's picture-envy, nor does he share Rembrandt's

faith in the book. In fact, this is not an argument about words *versus* pictures but rather about words *as* pictures. To declare that words are "the images of matter" is to perform some radical revaluations, since, in the normal operation of these arguments, it is pictoriality, at least when viewed from the perspective of the mediations demanded by language, that promises something more like real substance.

Bacon overturns these expectations by deploying a whole series of traditional accusations against pictures: image is pure decoration, as opposed to some sort of less clearly defined substance; image is idolatry, as opposed to some sort of true religion; image amounts to sublimated, or insufficiently sublimated, sexuality, as opposed to some more abstracted form of cathexis. Not that he is really all that interested in images per se (few writers who make the comparison are); rather, he manages to load down certain sorts of linguistic operation with all the weaknesses that have been ascribed to both word and picture. Scholasticism, which is the object of his critique here, becomes the site of both insubstantiality and fetishism. In fact, buried in the expression "life of reason and invention," which he proposes as the superior discursive practice, are traditional catchwords for language and visuality—logos and imagination—respectively. And it is Bacon's own textual work, which by producing "good emblem or portraiture," co-opts anything, whether of a moralizing or a representational kind, that pictures might have been thought to produce.

One of the differences between "The Invisible Collection" and these vignettes of written matter in which pictoriality gets exploited for the purpose of defining or celebrating the operation of text is that, unlike Montaigne or Bacon, Zweig is writing a *story*. Which turns his account of the matter into a more dynamic representation of the word-and-image problem, and a fuller one. In fact, in the hands of those who write

and those who theorize writing, there is the persistence of belief in a sort of synaesthetic utopia where words keep pushing themselves to a limit, where that limit turns out to be the image, and where words claim to encompass the image.

Beginning as early as the fourth century B.C., young orators were trained by being asked to provide elaborate descriptions of a picture. And in the collections that have survived, like the *Eikones* of the elder and younger Philostratus, the pictures are clearly fictitious—produced not by a painter but by the words that claim to be recapturing them. The objects of description in these remarkable texts emerge as complicated, elusive, enigmatic, and paradoxical, in ways that no actual pigment could ever realize. In a painting of Cupids gathering apples, for instance, we are told that you can hear the beating of their wings, you can smell the fragrance of the fruit, and you can tell that one pair of Cupids is beginning to fall in love with each other; the first kisses the apple before he throws it, and the other "intends to kiss it in his turn if he catches it and then to throw it back" (Philostratus the Elder, 1.6). In another depiction of a ball about to be tossed by boys, the stitches sewn on the ball convey to us that "when it is tossed in the air, the radiance emanating from it will lead us to compare it with the twinkling of stars" (Philostratus the Younger, 8). Elsewhere, the expression on Apollo's face reveals a whole paragraph of quite specific accusations the god is making concerning Hermes's theft of cattle, while the same face also represents simultaneously wrath, reconciliation, and suppressed laughter. Marsyas, in yet another picture, stands near a tree from which "he knows he will be suspended," and the figure who is going to flay him wears a grin "in anticipation of what he is about to do" either "because he is glad or because his mind swells in pride as he looks forward to the slaughter" (Philostratus the Younger, 2).

In sum, these pictures, which are really words, direct visual sense experience toward philosophical intellection. They provide impossible, nonvisual sense experiences. They record the invisible. They summon up absent pasts and futures. They provide multiple alternative possibilities for the characters' emotions, which is really a way of saying they depict conflicting emotions. The words describe pictures, but they do everything that pictures cannot do by themselves. And, of course, all the while they are *not* pictures.

Permit me to leap almost two thousand years, to Shakespeare's *Lucrece*. For the two-thirds of the poem that are devoted to the sexual action itself, the poem is a monument to the dangers and frustration of rhetoric—the rapist's elaborate arguments with himself and with Lucrece, her equally intricate counter-speeches (which only turn him on more), and the longest rhetorical tirade of all, after the grim event, as Lucrece apostrophizes opportunity, time, Tarquin, night, and the futility of making such speeches. She then spends two hundred lines in front of an elaborate painting depicting the fall of Troy, rendered as a poetic ekphrasis that contains, as always, both the visible (beauty, variety, the play of optics) and the invisible (speech, differences of personality, moral worth). After the ekphrasis, the heroine manages, by a mixture of speech and actions, to make an effective public declaration, to communicate love and sorrow to her husband and father, and in effect to produce the conditions that banish Tarquin's line and inaugurate the Roman Republic. What words have failed to do by themselves, the picture achieves, once the heroine puts it into words.

In both these cases, words about pictures play the role of pivot, whether toward discursive education or toward redemptive action. Just what forces are involved in that turning point I think "The Invisible Collection" may help us under-

stand. Take that primal scene in my movie: the great lover of art and expert on pictures is a man who can see nothing; he stares at sheet after sheet of white paper with what can only be described as blind faith; speaking to an unworthy audience, he creates vast verbal monuments that arise not out of any present sense experience—from which they are terminally disconnected—but out of memory and imagination; the product of all this is, depending on how you look at it, either a pathetic self-delusion or a definitive act of inward sight. In other words, the old man is a writer.

In short, Stefan Zweig, who was a maker of texts and not of pictures, created a fiction about an empty sheet of paper. To writers, whether in the second, seventeenth, or twenty-first centuries, an empty sheet (or screen, if you like) is no fiction but the fundamental condition of their craft. It might be a positive image—say, the tabula rasa of clearing away the distractions of ordinary life and the frictions offered by past models. But the empty sheet is much more likely to signal terror: the inability to write, the perishability of the word, and, especially, the emptiness of the word in a world of things (which, after all, appear to be more substantively rendered by the hand of a painter).

According to Zweig's fable, what enables the page to become full—and not only full but also substantial and durable—is a picture that predates and generates the word. And that, I would suggest, is the fable of all these writerly appropriations of picture. These are all stories about the birth of language, or, the birth of a particular kind or exercise of language, places where writers can entertain the idea of stepping outside the word so as to witness (or fantasize) its coming to be. Of course, given that these pictures are invented by the writer to begin with, one would have to say that this birth scene of language is the most satisfying nativity imaginable, one in which

the writer conceives, facilitates delivery, gives birth, and is born; acts, in other words, as father, mother, midwife, and infant all at once.

The *Eikones* were, after all, literally exercises in the development of an oratorical discourse. They exploit picture to create words. All the nonpictorial experiences that the ekphrases elicit from the paintings are linguistic: when the painted figures come alive, they signal it by speech; when individuals reveal themselves in conflicting or ambiguous ways, that is because a single image can be transformed into alternative strings of words; and when the speaker sums up his task, it is with the question, "what is the *logos* of the painting?" (Philostratus the Younger, 1.1). The picture must be promoted, then inscribed, then exploited, in order to produce *logos*.

Shakespeare is also going after something new in language by introducing his ekphrasis. It is not the narrator but the heroine who first decides to introduce the painting into the poem. After some five hundred lines of lamenting monologue, Lucrece exhausts herself and "she her plaints a little while doth stay, / Pausing for means to mourn some newer way" (1364–65). The means to mourn "some newer way," it turns out, is a special kind of interactive ekphrasis, explicitly described as the birth of a language. Lucrece berates the painter for giving Hecuba "so much grief, and not a tongue" (1463); and in response, she vows to "tune" the queen's woes with her own tongue. It is a play on that terrible figure of deprivation, the lamenting Philomela, whose tongue was cut out in order to prevent her expressions of grief—a figure alluded to in Lucrece's earlier rhetorical performances and central to Shakespeare's previously composed classical rhapsody, *Titus Andronicus*. The narrator concludes, "So Lucrece, set a-work, sad tales doth tell / To pencilled pensiveness and coloured sorrow, / She lends them words, and she their looks

doth borrow" (1496–98). While ekphrasis enables the heroine to conclude her futile rhetorical exercises and perform the requisite act of public display and sacrifice, it enables Shakespeare to pass from the birth of a poetic to the birth of a dramatic language.

Yet even with the promise of dramas to come, it must be noted that there is a crisis in Lucrece's contemplation of the painting that takes on a tone much different from the lofty tragedy of her eventual public sacrifice. She has been focusing in particular on the representation of Sinon, the pretended deserter from the Greek army who persuades the Trojans to admit the fatal horse. She notes the hypocrisy of the painted tears (painted in more than one sense) that the betrayer sheds, and from there she arrives at a climax of anger:

> Here, all enraged, such passion her assails,
> That patience is quite beaten from her breast.
> She tears the senseless Sinon with her nails,
> Comparing him to that unhappy guest
> Whose deed hath made herself herself detest.
> At last she smilingly with this gives o'er:
> "Fool, fool," quoth she, "his wounds will not be sore."
> (1562–68)

The high point, in other words, of the painting's power to inspire lament, poetry, and tragedy is its own mutilation at the hands of the engaged and believing ekphrastic observer. And, even more ignominiously, this defacement only serves to reveal how superficially—*literally*—the painting represents epic experience: Lucrece can deface the canvas, but she cannot cause a painted Sinon to suffer her anguish. On the face of it, considering both the frighteningly empty page of Zweig's collector and the vandalized surface of Lucrece's painting, these writers are depicting a condition of vulnerability from which

their own medium is supposed to be exempt. Yet, as we shall see later, these anxieties about loss, erasure, and silence cut both ways. For the moment, though, we must step backward toward a consideration of these questions in a mode more attuned to linear history.

Apples and Oranges

Apples and oranges, we are often told in the course of casual conversation, shouldn't be compared. Among those given to more acute investigation of language and thought, the legitimacy of such an assertion, or at least of its placement in the produce department, has been frequently challenged; and, since the argument of this book will depend on some quite particular exercises in similitude, it may be worth reminding ourselves of the problems lurking behind the cliché. As it happens, for the role they seem to be playing in this oft-repeated formula, apples and oranges are rather a curious pair. Romanians, we learn from Wikipedia, are warned against comparing grandmothers and machine guns, which not only provides a livelier image than the more widely diffused reference to fruits, but also establishes the principle that, for the purposes of disallowing false analogies, the two terms must be radically unrelated. Apples and oranges—both fruit, both sweet, both (roughly) spherical—might, after all, be quite reasonable objects of comparison.

But the case of words and images, or poems and paintings, or language and visuality, turns out to raise questions that are not quite covered by simply moving the comparables along an axis of similar and different—from cognate fruits, say, to wholly dissimilar family members and weapons. In this regard, it would be better to recollect that in some languages oranges are themselves referred to as a form of apple (typically, a *Chinese* apple), or else to propose the problematic comparison of oranges and grapefruits, given that the grapefruit is itself a product of hybridizing the orange. The question, in short, is what happens when one term of the comparison has already been defined or created by the other? When, in other words, the two terms are interconnected at their core and the very premise of independence between them, which seems a prerequisite for the logic of similitude, turns out to be compromised.

"Painting is mute poetry, poetry a speaking picture," credited to Simonides of Ceos, first appears in Plutarch's essay *On the Glory of Athens* (346F); and already in that nutshell we can observe many of the difficulties attendant upon these sorts of pronouncements. The heritage of the Simonides lines plucks them out of Plutarch's context just as he had in turn plucked them out of some unknown context in the original. In fact, the subject is neither poets nor painters but historians, whom Plutarch sees as bringing the past into the present; thus the ultimate compliment that he can pay to Thucydides is to declare his words as effective in conveying the experience and the emotion of the Battle of Mantineia as was Euphranor's painted version. In that slide of reference there is also a truth: the parallel and contrast of ζογραφίας and ποίησις, with its sense of rendering what is absent real, will provide—or seem to provide—at least as good a definition for the poet as for the historian. The other epochal expression on the subject hardly

needs even that much introduction. Horace's "as a painting, so a poem," generally known in its original form as *ut pictura poesis* and meaning either that a poem *is* or *will be* or *should be* like a picture (quite different possibilities; in fact, *erit* was sometimes inserted so as to nail the matter down), makes a claim that is about as frequently repeated as any assertion that touches upon culture, representation, or the arts. Like the Simonides phrase, it is embedded in an argument that was not always recognized by those legions who quoted it.

"Poetry is a speaking picture" and *ut pictura poesis* attain great cultural weight because each of them purports to be a whole poetics in a nutshell, which should remind us that the parallel between the arts is part of a fundamental definitional activity, and not just an adornment appropriate to certain highly sophisticated productions like the paintings of Rembrandt and Poussin or the writings of Montaigne and Bacon mentioned in the previous chapter. But this is also where the problem begins, because these famous phrases are not very *good* definitions of poetry. In place of a clear description, we are left with tropes and tautologies. Whether it is Simonides's metaphor or Horace's simile, whenever this claim is made, explicitly or implicitly, presumed or elaborated, whether by an ancient theorist or a modern scholar, it takes the form of figural language, with all the power and unreliability that such a usage implies. Simonides's statement is—as it means to be—a perfect circle, which also makes it a perfect tautology. The arts, like other things, cannot be defined from inside themselves. One of the impulses to overcome this problem among those defining poetry or painting consists in the appeal to the other art. But this attempted definition merely displaces the perplexity into a mirror-space whose own definitional history is characterized by perfectly complementary problems. So the claim that painting is mute poetry and poetry speaking paint-

ing ends up affirming a rhetorical community between the arts while in fact demonstrating that neither of the arts can explain the other or itself.

At least Simonides seems to be even-handed. The other slogan—*ut pictura poesis*—is unmistakably unidirectional, and it becomes the spearhead of a very different set of rhetorical operations. "As painting, so poetry . . ." can introduce a statement about poetry only. Like any rhetorical analogy, it takes one of the terms for granted so as to prove something about the other. It is hardly a coincidence that the term taken for granted is *pictura*. First of all, despite occasional exceptions, this whole discourse is overwhelmingly the property of writers and not painters, for whom it is convenient to imagine *pictura* as whatever they want it to be—in most cases as "simpler," more natural, more immediate, while *poesis* is constituted as more complex, more sophisticated, and (often) nobler. So the many claims—from Aristotle to Horace, Sidney, and onward—founded on "as painting is, so is poetry" will always have a shell game aspect to them. I declare without needing to prove the point that x is true of pictures; I make a number of rhetorical moves and demonstrate that it is also true of poems. And the x is especially labile, since it refers to a set of properties that word-makers have imposed on pictures.

But if both Horace and Simonides reveal an inability to establish the relationship of poetry and painting even as they try to base their claims for poetics on it (or at least are thought to have done by posterity), it is not merely a failure of their rhetoric or their reasoning. The problem goes back to what we might call the ur-source for poetics, Plato's *Republic*, where—famously—Socrates banishes the poets from the ideal state. Ultimately he advances a number of reasons for taking this step, but the first and most fully reasoned reason—the only one that gets the force of Socratic syllogistic thinking—runs

as follows. There are two kinds of reality: the ultimate reality of the world of forms, in which there can be only one prototype for everything that exists, and the material reality constructed after those ideal types. So, to use Socrates's example, there is the *idea* of the bed, and there are the cabinetmakers' various actual beds. God and the cabinetmaker are real makers, though of different kinds. But there is one more option: "There are these three beds: one in nature, which we might say god makes . . . , one which the carpenter makes, . . . and one which the *painter* makes" (597B; my emphasis).

Where does this painter come from? If the ultimate goal is to delegitimize poetry, and if the painter is the stand-in that makes such a move logical, the beginning of the process is the hierarchical construction of reality around the notion of the δημιουργός, which literally means something like "public craftsman," but which Plato has already in the *Timaeus* transmuted into an equivalent for θεός, or God (28A). That slide from urban contractor to supreme divinity, besides being breathtakingly audacious, has a number of logical consequences. If the emphasis on *making*—in other words, defining the particles of reality as having been products of construction—has the effect of linking God and the cabinetmaker, it isn't so much that Socrates wishes to elevate the practice of popular craft. Rather, he has managed to construct an all-or-nothing grid on which each of the two possible *demiourgoi* either makes everything in the universe or else only one single thing—in this case, furniture. This move completely crowds out the possibility of a more conceptual form of creation that is, first of all, not so mechanical and, secondly, capable of turning its skills toward a wide variety of products.

The hidden enemy here—unspoken, but generative of this whole syllogistic edifice—is the idea that the perfect example of the mortal as *demiourgos* might be none other than

the poet. Most of these claims, like Sidney's poet who creates another nature, including "the heroes, demi-gods, cyclops, chimeras, furies, and such like" (14) come from later periods; but it is clear even in Plato's own *Ion*, which wrestles with this notion more directly, that such a vision of poetic invention was already well established. Yet once the arguments in the *Republic* have shunted creation into a transcendent track and a mechanical track, there is no room for the poet. Which leads to the initial description of third-order reality, when Socrates induces Glaucon to realize that there is, after all, one procedure whereby an ordinary person might perform the role of a universal creator, and not just that of a cabinetmaker:

> "Don't you realize that you might yourself be able to make all these things in a way?"
>
> "What way?"
>
> "Not a difficult one, but contrived in many ways and quickly—quickest of all, perhaps, if you will pick up a mirror and carry it round. You'll soon create the sun and the objects in the sky, and the earth, and yourself and all the other animals and articles and plants and everything we were talking about." (596D)

Poetry returns in the midst of its suppression: the language here is drawn from creation epics, but the medium is bathetically reduced to the operations of a galloping functionary who carries a reflecting glass around the whole world of phenomena.

It's handy as well that Socrates has managed to bring things down from three dimensions to two: the chair reflected in the mirror, in other words, may look good, but you can't sit in it. You can't, of course, sit in the *idea* of the chair either, but (according to this system) that's not what ideas are for. For our purposes, what is most significant is that it is a short

step from the mirror to the painting—a transit that, among other things, neatly elides the difference between a natural form of replication and one that is the product of human effort. But rather than conferring craftsmanlike credit on the painter, the derivation via the mirror turns the painter into a kind of reality-Xeroxing *idiot savant*. From this point in the argument, it is that issue of replication, and particularly the assumption that it is all but involuntary, that shapes the attack on poetry. For others, to be sure, painting will be a lofty intellectual activity precisely because, unlike sculpture, it does not merely simulate reality but requires the creation of a complex algorithm that renders the three-dimensional universe into two. And for those who celebrate painting on such grounds, this will become the basis for all those triumphant birds-and-grapes stories—already in wide circulation by Plato's time—about the miracles achieved by the precise form of verisimilitude that Socrates deplores.

In fact, though, Socrates isn't really interested in pictorial matters per se. The purpose of the analogy, whatever violence it does to painterliness, is to set forth the activity of poets as sentenced to operating in the merely material realm over which it exercises its skills in a manner that is scarcely more than a reflex action. Not that poetry is his ultimate goal either. The real issue is philosophy—whose realm is construed as transcendent and whose operations are construed as possessing all the wisdom and τέχνη that walking up and down the streets of Athens with a mirror cannot be said to embody—and, more specifically in the case of this dialogue, the imagining of the kind of political utopia that might be ruled by philosophy.

Those slippery slides of analogy are fundamental to the *Nachleben* of the *Republic* and to the history of poetics that follows from it. Having shifted the argument from poetry to

painting, Socrates plays fast and loose with logic when it comes time to resume his (supposedly) real subject. He either asserts the equivalence with no basis: "then the tragic poet *also*, since he is an imitator, will be in the same position, third in order from king and truth, and so will all other imitators be" (597E, emphasis mine). Or he asserts it on a subject where it is fairly apparent that poetry and painting are quite different, as when he adduces the dangerous tendency of poets to create characters whose minds waver, when in fact this sort of multiplicity is precisely what is impossible to depict in mute visual form. Or else he further contaminates the distinction by speaking of the poet, now supposedly independent from the painter analogy, as an image-maker (εἰδολόν δεμιούργός). In short, this first and most influential—if notoriously negative—account of poetry is not an account of poetry at all but of painting. At the very instant when poetics is born, in other words, the baby is exchanged in the cradle.

But why should a particular shell game, born of Socrates's wish to banish the poets because philosophy envies poetry or because he mistrusts the pleasure principle involved in poetic expression (topics to which I shall return), have such a lastingly definitive effect on the discourses of literature and the visual arts? Not surprisingly, it all comes down to mimesis. What gives Socrates the occasion, as well as the reason, for condemning the poet in the person of the painter is the fact that he has defined poetry as mimetic or imitative. "So the art of imitation," he says, "is an inferior thing, its associate is inferior, and its products are inferior" (603B). What the painter most immediately provides is the notion of imitation in its most limited sense, offering a definition of poetry as *mere* imitation and *mere* decoration. Mere imitation produces objects at three removes from reality, while mere decoration offers a dangerously seductive set of appearances in place of truth.

Throughout the long tradition begun here, the definitions of poetry and painting *and* the parallel between them will continue to be embarrassed by unresolved questions. When Socrates deals the painter from the bottom of the deck, he is, among other things, attempting to demean poetry by connecting it to a visual form of production that could be seen in various ways as mechanical—not only in the sense of its labor arrangements but also in the very principle of replication or copying. The painter's work is understood to involve an imitative dimension that is essential and then a decorative dimension that is supplementary. There are problems with this notion of imitation even before we get to poetry, in witness whereof I cite a later authority, but one who is himself basing his aesthetic ideas on Greek theory and practice. Pliny reports that when the Romans were entertaining the Teuton ambassador, they proudly showed him a statue of an old shepherd that was exhibited in the Forum. Instead of being impressed by this piece of Hellenistic genre work, the northern visitor declared that, since he wouldn't even want a *real* Old Shepherd in his house, why on earth would he want a *statue* of one (35.25)? It's no accident that this point of view is attributed to a barbarian. No cultivated Roman—that is, none of Pliny's readers—would imagine that the value of an artwork existed on some sort of descending scale from the value of its real-life subject. But this, *mutatis mutandis*, is precisely what Socrates assumes by postulating his downward hierarchy, from the idea to the material object to the painting.

What is missing from the "Teutonic" aesthetic is precisely what Socrates wishes to deny to poets (and, along the way, painters)—namely, the notion that the making of an artwork involves special skills and disciplines that enable the creative project to have its own standards for judgment completely independent of those appropriate to the real-world objects that

it is (let's allow ourselves the use of the word) *imitating*. This is the *techne* that lies at the heart of the gulf he wishes to open between poetry and philosophy. To be sure, painting can be seen to possess a rigorously instituted set of practices; still, these can easily be dismissed as being merely mechanical, rather than being subject to the sort of ratiocinative and dialectical work that gets privileged as Socratic philosophy. Resolve that argument as one may, when we shift the focus to poetry, whatever its form of *techne* might be, there is nothing mechanical about it. Once again, painting serves as a distorting mirror.

But the real fallacies surface when we leave this mirror behind and concentrate on the arguments about poetry in itself. Problematize it as one will, there *is* a commonsensical way in which a certain kind of painting, from Apelles to, say, Cézanne, imitates. But even this level of clarity disappears when Socrates applies the term to poetry. To begin with, what kind of poetry? Plato's references, in the *Republic* and elsewhere, frequently suggest that he is thinking of dramatic representations, not only of the tragedians but also of Homer's work as it might be expounded by a rhapsode like Ion. Viewed in that light, poetry *imitates* in the person of an individual who is neither Homer nor Achilles but who pretends to speak with the voice either of the poet or the fictional character. (For more on this, see chapter 4.) In either case, the term *mimesis* describes something quite simple, even banal—essentially, impersonation; and in either case, it is quite easy to argue that such a procedure is based on falsehood. But even within Plato's work, the operations of poetry are by no means limited to this exercise: the quotations from poets and tragedians, as well as the anxieties concerning their power over the audience, suggest something far more like our own postclassical vision of poetry, whose effects are staged most significantly within the minds of listeners and readers.

Once there are no actors engaged in impersonations—and, needless to say, the heritage of these arguments in the *Republic* traverses many centuries in which poetry is decisively removed from such a practice—the concept of mimesis loses any such literal force. It is then thrown back on a quite different, and far more problematic, model of imitation, which is offered by language itself, and specifically in the relations between words and things, very much along the lines that Plato himself theorized in the *Cratylus* (390E–427D). In effect, the argument based on actors or rhapsodes is much like the argument based on painters, functioning as a partial (in every sense) analogy that makes the negative case against poetry far easier to argue while obscuring the real functioning of poetry. Hence the metonym of mimesis-as-performance gives way to the metaphor of mimesis-as-visual-rendering. Which is to say that what the poet and painter have in common is not really *imitation*—because words do not imitate things—but rather *representation*. So the definition of poetry as mimesis will *always* require the phantom painter in order to declare (whether for good or ill) that poetry replicates reality and to sidestep the more heavily mediated problems of linguistic representation.

I say *always*, but it is a mistake to suggest something continuous and unchanging. The story I am telling here is partly about ideas contained within a Platonic dialogue, but the larger part has to do with consequences that the reading, rereading, and misreading of the dialogue bring about in later times. This effect has already been suggested when speaking about the slide from an emphasis on poetry as predominantly performed toward something more like an inwardly received experience, whatever the means by which it was generated. To put it simply: what makes sense for Plato, given the widespread practice of the rhapsode or the tragic actors, finds itself

mutated and metaphorized by later readers who wish to see Plato as a universal lawgiver (even when they disagree with him) but whose experience of poetry is completely different. The heritage of canonical texts, in other words, may best be understood as a kind of Mendelian inheritance, in which dominant and recessive genes work their way through generations via complex pathways of appearance and disappearance.

The most obvious of these circumstances—and we shall see it in many forms—is the fact that the arguments against poetry in the *Republic*, and (more important for us) the use of the equation with painting in order to justify these arguments, will be transformed at later moments into arguments in behalf of poetry, or at least in behalf of certain notions of poetry. Plato himself sets this paradoxical process in motion because elsewhere (especially in the *Ion*) he posits an extravagantly sublime vision of poetic creation. Within the somewhat tortured logic of his argument, this vision, involving magnetic rings of inspiration extending out from the gods to the spectators, turns out to be a bad thing because it defines poetry as a kind of madness rather than as a sober discipline like philosophy. But it's easy to see how, with alternative agendas for the poet, this disparagement might turn into high praise indeed.

A more intricate pathway of developments, and more relevant to our subject, can be seen in one particular attribute that Socrates, yet again, assigns to poetry on the basis of the analogy to painting:

> "If you look at a bed from the side or from the front or from any point, does it vary from itself or only appear different, and likewise with other objects?"
>
> "It appears different, but isn't really so."
>
> "Now consider this point. Which is painting concerned with—to imitate the reality as it is or the appear-

ance as it appears? Is it an imitation of appearance or of reality?"

"Of appearance."

"The art of imitation therefore is far removed from the real, and, it seems, achieves all its results because it grasps only a small part of each object, and an image at that." (598A)

Visuality itself comes to be understood as relativistic, quite apart from any artistic operations upon it. And from there, Socrates needs take only a short step to characterizing the work of the painter as an exploitation of these labile qualities:

"A thing may seem straight or crooked according to whether it is seen in or out of water. Similarly with the concave and convex, because of visual error connected with colours. This is evidently a sort of total mental confusion: and it's this natural experience that perspective drawing exploits with its magic, and conjuring tricks too, and many other such devices." (602D)

Under the expression rendered here as "perspective drawing" lurks a history of multiple and shifting meanings. Plato's term is σκιαγραφία—roughly, "shadow-painting"—and, in the whole history of ancient art, there may be no concept that has proved more difficult to pin down. Like so many terms in the long heritage of antiquity, *skiagraphia* finds itself astride significant gaps: it refers to the practice of the visual arts, but it is coined, or at least fleshed out, by practitioners of the verbal arts; further, the practice itself appears at one moment of history, but it is reflected upon (again, of course, in words) at many subsequent moments. And these two sorts of gap—one across media, the other across time—complicate each other. When modern scholars try to determine what *skiagraphia*

actually was, they arrive at a series of different, though often overlapping hypotheses: it has something to do with color fields, with light and shadow (the Latin equivalent term seems to be *lumen et umbrae*), with creating the illusion of depth, with theatrical illusionism, with foreshortening. But what these efforts really tell us is that our (necessarily verbal) archive consists almost entirely of texts in which *skiagraphia* is being invoked for some metaphorical purpose in the light of which the visual arts count for very little.

In other words, we are back where we started: with a rhetorical strategy that exploits what is presumed to be pictorial practice for the making of claims about linguistic practice. For the philosophers—and the passage cited above from the *Republic* is one of several references to the practice in the work of Plato and Aristotle—*skiagraphia* nearly always appears in the context of deception or, at the very least, misapprehension. In the *Theaetetus*, it is a way of talking about the epistemological limits of sense perception (208E); in the *Critias*, it is an index to the difference between the highly approximate forms of representation that satisfy us in the depiction of the natural world as opposed to the precision we expect in portraiture (107C–D); and in book 9 of the *Republic* (586B), it is associated with the delusory pleasures of the multitude. Aristotle, for his part, refers to these painterly practices in connection with inferior forms of speech-making and in his definition of things that, even if they are real, seem unreal, "like *skiagraphia* or dreams" (*Metaphysics* 1024B).

Yet at the same time that *skiagraphia* serves as a convenient visual analogue with which to critique types of misperception or trickery that *aren't* visual, it also summons up a set of intricate, even awe-inspiring possibilities in artistic practice that not only escape any simplistic moralizing purposes but also develop their own complicated relevances to the operations of

40

poetry. In this sense, it is the very uncertainty of the term, even within antiquity, that inspires writers to perform meditations that remove it definitively from the realm of the easy analogy. In the long run of art history, *skiagraphia* would come to be associated with everything from Albertian perspective to impressionist pointillism. But more relevant to our purposes is the fact that in a number of respects it contributes to an account of literary practice that is far removed from simple censure.

First of all, *skiagraphia* is understood as a sophisticated set of techniques involving color, whereby remarkable illusionistic effects of representational magic are achieved. Within the practice of painting, the specifics are much debated, as between the mixing of pigments or the overlaying of hues or the close juxtaposition of tiny fields of different colors. Whatever may have been the actual practice, or combination of practices, this account veers decisively away from more conventional notions concerning color, which were either technological—that is, based on the materials that artists actually had at their disposal—or else straightforwardly mimetic—that is, based on artists' ability to imitate colors in the real world. Once artists are being celebrated (or, alternatively, chastised) because they have turned color into an *effect*, we are already in a universe of painterly metaphorics.

And that brings us back to words. Color is one of the most fundamental visual metaphors that gets applied to language—so fundamental that we are liable to forget that it is a metaphor. The notion of the "colors of rhetoric," which appears as early as Geoffrey of Vinsauf's book of that name written in the twelfth century, speaks to a whole set of ways in which language performs some sort of surplus in relation to denotative meaning (again, this can be viewed *in bono* or *in malo*). And long before that, Socrates in the *Republic* had already used his painter analogy so as to characterize color as signifying the

merely decorative aspect of language. In a quite different, and more modern, sense, we might understand color as the most powerful test case for the problem of linguistic representation itself, raising questions as to whether the thing we agree to call *blue* is the same experience from one speaker of the language to another, not to mention the possibility that some languages possess multiple and differentiated terms in the same space— say, *blu*, *celeste*, and *azzurro*—which suggests (improbably) that their eyes might actually function differently.

But the quality of *skiagraphia* that excites the fullest metaphorical activity derives from the belief that it was a technique whose effects depended on maneuvering the distance between the viewer and the art object. In both the *Theaetetus* (208E) and the *Parmenides* (165C–D), the notion that pictures appear different when viewed from close up rather than far away is used to explain the ways in which a single entity can authentically possess different qualities. In these instances, there is no ethical dimension, but elsewhere this doubleness becomes duplicity, as in the *Laws*, where the just individual is characterized as bringing clarity to the "illusory pictures" painted by those who use distance to confuse the populace (663B–C). Aristotle will make a different sort of crossover into discursive territory when he compares public oratory to pictures viewed at a distance, whereas arguments before a judge are said to resemble pictures viewed close up, with the strong implication that the latter is more reliable (*Rhetoric* 3.12.5).

In the *Republic*, to return to that foundational text, the manipulation of point of view, while based on natural properties of vision, counts as a very deliberate sort of deception:

> For example, a painter, we say, will paint us a cobbler, a carpenter, and other craftsmen, though he himself has no expertness in any of these arts, but nevertheless if he were

a good painter, by exhibiting at a distance his picture of
a carpenter he would deceive children and foolish men,
and make them believe it to be a real carpenter. (598C)

This is a critical part of the argument against poetry, because
Plato uses the fact that the same thing can look different from
different vantage points as an analogy to the dangerously
conflicted and changeable state of imitative poets and their
audiences. When the visual is invoked, the physical space of
beholding becomes the metaphoric vehicle for all the glories
and anxieties attendant upon the realization that every artistic
object becomes at least in part the property of those who ex-
perience it. This is, after all, the point of the original *ut pictura
poesis* passage (about which I shall have more to say below):
"Poetry is like painting. Some attracts you more if you stand
near, some if you're further off. One picture likes a dark place,
one will need to be seen in the light, because it's not afraid of
the critic's sharp judgement" (360–64). In effect, the physical
circumstances of seeing a picture are thought to offer a simpli-
fying analogy for what happens to listeners, or readers, when
they experience a poem.

What makes this facet of the analogy especially interest-
ing is that, like so much else among these ancient pronounce-
ments, it develops a Renaissance converse. After all, the great
fifteenth- and sixteenth-century intellectual adventure of the
visual arts is connected to the development of linear perspec-
tive, which is to say, the activity of theorizing the space of be-
holding. Perhaps it is too grandiose to claim that the entire
Renaissance literature on perspective has a reversed Horatian
subtext of *ut poesis pictura*. But it is certainly the case, for in-
stance in Alberti, that a description of the phenomena—the
tricks, really—that operate between the viewer and a two-
dimensional art object becomes the occasion for a fuller ac-

count of what we might call perceptual relativism, which is, after all, the point of Horace's analogy.

It takes another century to see in Vasari a more nearly explicit mirror-image of Horace's analogy:

> And thus every craftsman should take notice of how we realize from experience that all works which are to be viewed from a distance . . . are more striking and forceful if brilliantly roughed out rather than highly finished; and as well as the way that distance produces this effect, it also seems that very often work in the rough, brought to birth in an instant from the art's inspired frenzy, can express its maker's concept in just a few strokes. . . . And anyone who knows that all the arts of design, not just painting, are similar to poetry also knows that just as poems dictated by poetic frenzy are true and excellent, and better than those which are laboured, so the products of men who excel in the arts of design are better when they are created instantaneously on frenzied impulse. (1:274)

Vasari recombines the elements of the analogy by introducing a Platonic strand from the *Ion* and the *Phaedrus*, which he turns into his own *ut poesis pictura*. That is, he appropriates the highly valorized category of poetic frenzy for the visual artist. But it is no coincidence that Vasari should draw Horatian-style analogies to poetry when he is speaking of the distances from which art objects are seen. The invention of perspective has by Vasari's time turned into a whole hermeneutics of viewpoint. And Vasari translates this hermeneutical material into the justification for an inventive, or individualist, or mannerist style—one which values the artist's brilliant, inspired stroke and takes it for granted that art objects become different under observation.

44

But the afterlife of the *Ars poetica* in this story goes far beyond the particular elucidation that Horace offers in the lines following upon *ut pictura poesis*. What we have observed in tracing this whole genealogy of interart comparisons is that a set of strictures that begin with an unstable analogy and that are intended to place limits on the operations of the creative imagination develop an afterlife that both complicates the analogy—making it, for instance, more reciprocal—and goes so far as virtually to contradict the restrictive purpose for which it was originally proposed. For this kind of swerve, the *Ars poetica* (more even than *skiagraphia*) offers a paradigmatic example. Three-quarters of the way through the poem, Horace introduces the famous formula—a poem *is*, or *will be*, or *should be* like a picture. But 360 lines earlier (that is, in verse 1), he has already operated in the analogical realm:

> Suppose a painter chose to couple a horse's neck with a human head, and to place feathers of various kinds on limbs collected from all over the place so that what started out on top as a beautiful woman ended in a repulsively ugly fish below. Believe me, . . . a book will appear very much like that if its features are invented fantastically in such a way that neither head nor foot is given enough shape to produce unity. (1–9)

So Horace *performs* the analogy before he enunciates it. And the two enactments are quite different. *Ut pictura poesis* is followed by a series of rather oblique elucidations: not only in regard to distance from the observer, as we have already seen, but other qualities—darkness and light, pleasing once versus pleasing a thousand times—that leave the reader in confusion regarding what precise qualities of pictures are being urged upon poets and how the poet who took this advice would convert these pictorial properties into poetical ones. The fish-

woman, on the other hand, seems to offer something far more substantial. Poems, she is telling us, have an inevitable organic shape as unitary as the healthy human body. Poetic decorum equals physical health. Painters are the pure conduits through which this act of representation flows, and poets should perform their job similarly. Words turned into an image do a more powerful job than words turned into a simile. In the realm where poems and pictures are supposed to explain each other, it turns out that practice may be the most lucid form of theory, and theory may turn out to be mystified practice.

There is, however, a Hitchcockian MacGuffin within the apparently vivid message-making of that opening analogy. Immediately after the poet has painted his picture, so to speak, of a monstrous body and then, with the authoritative voice of the lawgiver, has nailed down its meaning as referring to the unshapely or heterogeneous or indecorous poem, the very texture of his own writing changes: "Pictoribus atque poetis / quidlibet audendi semper fuit aequa potestas" (9–10; "Painters and poets have always been given an equal power to dare anything they please"). Within the Epistle, it's a strange turn, and editors have sometimes responded by putting this sentence in quotation marks, as though suddenly (and uniquely in the text of the poem) there was a heckler in the audience contesting the rigors of Horace's strictures, and the heckler's voice somehow got spliced into the final work. (Similarly, translators often add a *but*, though it is absent in the Latin.)

However one might resolve this contradiction inside the Horatian economies, this logical gap becomes the place— *topos*, if you like—where a vast amount of postclassical cultural history will insert itself. As this curiously interjected sentence gets parsed, it takes on two meanings that stand in a jagged relationship to each other: one concerning the *equation* between poets and painters and the other concerning

46

the ability of each group to practice its art *audaciously*. What comes together here is a parallelism of the arts precisely on the subject of freedom in representation—all of this paradoxically under the quite contrasting rubric of logic and decorum, which appears to be the poem's "real" message. In effect, the two contradictory positions, making arguments for and against artistic liberty, each by reference to orderliness as defined via the norm of nature, seek an authority in Horace that is intrinsically contradictory.

With all this paradox, the *Ars poetica* has pre-mapped some millennia of debates that will launch this particular authority like a shuttlecock between attacks and defenses, between poems and paintings. Horace, after all, was talking about a painting that shouldn't, or even couldn't, happen, not to mention the fact that he wasn't really talking about paintings at all; and even after (unwarily?) opening the door to total freedom, he immediately reverts to a sense of strict limitation: "sed non ut placidis coeant immitia, non ut / serpentes auibus geminentur, tigribus agni" (12–13; "not so the wild and tame should ever mate, Or snakes couple with birds, or lambs with tigers"). Yet as early as 1370, Cennino Cennini on the opening page of his book of instructions for the artist alludes to Horace as though the Roman poet had given painters the freedom to produce monsters "secondo sua fantasia" (1). In Francisco de Hollanda's dialogue on painting set in the 1530s, a Spanish artist named Zapata complains about seeing painters produce "a thousand monsters and animals, some of them with a woman's face and the lower parts and tail of a fish, others with the arms of tigers and with wings, or with a man's face; anything in fact that delights the painter's fancy and has never existed" (60). It is highly unlikely that he was seeing illustrated versions of the *Ars poetica*. Rather Horace's literary criticism was conditioning his awareness of modern painting. It is Michelangelo

himself, the star speaker in the dialogue, who responds by quoting Horace, but very selectively: "Poets and painters have always enjoyed recognized rights to venture on what they will," which he then turns into a justification for painterly license. "Whenever a great painter makes a work which seems to be artificial and false, this falseness is truth" (61), he declares, and goes on to celebrate an intricate—literally grotesque—set of corporeal monstrosities. Horace's analogy has become the Renaissance's reality; and in the process what was specifically forbidden to the poet gets chartered and justified by ancient authority when it is applied to the painter.

Meanwhile, back in literature, allusions to the phrase, along with its pictorial baggage, form a recurrent grounding for both the anxieties and the celebrations surrounding imaginative license. So Montaigne reflects on his notably heterogeneous and self-created medium (in "Of Friendship"): "What are these things of mine, in truth, but grotesques and monstrous bodies, pieced together of divers members, without definite shape, having no order, sequence, or proportion other than accidental?" (135). At which point, with his usual insouciance about authorities, he drops in a quotation: "A beautiful woman above comes to an end as a fish below," except that he has caused the disapprovingly hypothetical subjunctive in the Horatian original to swerve into a simple indicative. And when Sir Philip Sidney places this set of permissions at the center of his *Apology for Poetry*—"Only the poet, disdaining to be tied to any such subjection, lifted up with the vigour of his own invention, doth grow, in effect, into another nature" (14)—it is clearly the permission that is given by Horace and by painters (the former more reluctantly, we must presume, than the latter), that makes his whole project possible.

Between Socrates and Horace, in short, we can observe a classical tradition that offers 180 degrees of possibilities for

defining poetry via painting. In the former case, pictorial mimesis is the slavish and yet suspect medium that by analogy sentences the literary act to a kind of tertiary status in relation to reality. In the latter case, the painter's ability to create imaginative fictions that are not subject to the mediations of language nor, on the other hand, to the limitations offered by natural or material reality, forms the grounding for the poet's wish to escape from the merely imitative. Or perhaps it is 360 degrees: both of these opposing accounts from the canonical classics will deliver a vision of poetry that is unsettled by its relationship to mimesis and that is tautologically dependent on painting in order to expound its own understanding of itself.

If this word-and-image discourse remains so insistently labile through a millennium or two, it is precisely because the *Ars poetica* has offered both precept and performance as regards the analogy. Whatever the meaning of *ut pictura poesis*, the imagistic opening lines of the Epistle have enacted a sort of freedom. As a result, the envelope that constrains poets or painters within their single medium comes to be identified with the envelope that keeps them separate from each other. Horace, in fact, is constructing a sort of meta-monstrosity: that is, the appallingly composite being that he hypothesizes is performing its own composite work as an analogy from painting that gets applied to poetry. And in that act of identification the boundary line of analogy itself begins to dissolve as metaphor slides toward metonym and poet toward painter.

But Horace isn't the only performer in this field. Indeed, in the work of two other supremely influential classical authors, what got labeled as grotesque in the *Ars poetica* was on its way to becoming canonical in some literary discourses that were attempting to define and, especially, to overrun the boundaries by which visuality limits language. To take the first case, there

was, as it happens, a visual artist from the venerable Greek past whose fame precisely rested on a composite painting:

> Zeuxis [Pliny tells us in his *Natural History*] . . . , was so scrupulously careful that when he was going to produce a picture for the city of Girgenti to dedicate at the public cost in the temple of Lacinian Hera he held an inspection of maidens of the place paraded naked and chose five, for the purpose of reproducing in the picture the most admirable points in the form of each. (35.64)

This painting of Helen—doubtless lost even by the time Pliny wrote these lines, if it ever existed at all—will have an extraordinarily active career in the imaginations of writers from Cicero deep into the Renaissance.

Now, the second case: while the Zeuxis painting may seek to render the Horatian monstrosity beautiful, another highly visible figure, Horace's younger contemporary, is conceiving of an entire epic universe based on the image of beings in a composite condition between the human and the animal, between the good, the bad, and the ugly. I am referring, of course, to Ovid's *Metamorphoses*, source for the historically irresistible notion that magical transformation, generally understood not only as a sequence of different forms but also as their momentary simultaneity, is somehow the key to identity and to the nature of things.

Now I very much like the idea of a chronological troika in which Zeuxis paints the modular *Helen* around 400 B.C., Horace exploits him as a bad example to poets around 10 or 15 B.C., and Ovid a decade later takes up the challenge of disseminating a whole poetic mode by following exactly what his rule-making predecessor proscribed. But my real arguments are not about a direct line of influence; rather they concern the persistent inextricability of the painter from the theory and prac-

tice of writing, as well as the persistent fascination of the monstrous, or composite, art object that emerges from this tangle.

As Ovid narrates it, the very first literal transformation in the history of the world is also the first one in the poem. Lycaon has dared to serve the god human flesh to eat, thereby turning piety into abomination as he translates holy sacrifice into cannibalism. Even in his human form he was already, in effect, the ravening beast that his vulpine name designated. His punishment at the hands of Jupiter is thus virtually a self-induced metamorphosis. But the linguistic change is decisive: as a beastly human being, he was *notus feritate*—famed for savagery; as a wolf, whose process of change is lovingly and gorily described, he is *feritatis imago*—the picture of savagery (1.198, 1.239). This instance, which is repeated both verbatim and in more elaborated ways through the poem, I offer as a way of suggesting that Ovidian metamorphosis represents an attempt, as literal as possible, to turn language into image or, to put it another way, to turn words into things.

Metamorphosis turns Lycaon into his name, like dozens of other victims of transformation. But the metamorph/metonym is not just the image of a word; it is the image of a whole narrative process. Ovidian transformation turns poetic narrative into image and thereby trumps the painter at the unplayable game of capturing temporality in a picture. A painter cannot paint time, and a poem cannot be a picture: those are the impossibilities on which Ovid's invention rests. To which we might add that the poem, with its hundred-plus stories, narratives within narratives sometimes to the third power, and its ambition to be a *carmen perpetuum* coming close to a repetition compulsion, has its own way of enshrining the impossibility of narrative. Metamorphosis enters this set of paradoxes as partly the problem and partly the solution. It is a double of narrative, potentially appearing as part of a logical sequence,

arising out of what came before and moving the action toward crisis or resolution. But more often it is the death of narrative, or the signal that it is impossible to continue the narrative in the terms—typically human terms—that have characterized its causalities up to that time.

When Arachne becomes a spider or Niobe a weeping rock, when Jupiter-as-a-bull deceives Europa just as the image of the bull on the tapestry deceives the viewer, when Tereus, Procne, and Philomela turn into mutually exclusive birds at the end of their harrowing story, or when Pygmalion's statue becomes a living woman at the end of his story, metamorphosis both enshrines and replaces narrative, providing the image for which sequential discourse has provided the words. It is a kind of pictorial literalization and reinvention of metaphor, a *figura* aspiring to be real.

That is why the word *imago* plays such an important role. In Lycaon's case the matter was fairly simple: he was first figuratively beastly and then *feritatis imago*. In the case of a more famous story, image does not merely *record* the metamorphic narrative, it *is* the narrative. "Visae correptus imagine formae / spem sine corpore amat, corpus putat esse, quod umbra est" (3.416–17; "Seized by the image of visible beauty, he loves a hope without a body and thinks that to be a body which is only a shadow"). In effect, Narcissus's mirror-image is his own metamorphic form. Like other more literal metamorphoses, it opposes linear narrative, here embodied in the prospect of union with Echo and frustrated by the circularity, tautology, and (once again) the repetition compulsion that keeps Narcissus by the edge of the pool and keeps the language of the episode so repetitive. This *imago*-metamorphosis captures an essence as surely as does Lycaon's, though it is much more universal: not just the realization of metaphors for a particular subject but rather the universal case of subjectivity—the self

that the famous oracle enjoined all human beings to know. (Remember that Narcissus lives under the curse of Tiresias that he would have long life "si se non noverit" [3.348]). That, too, has been crystallized as an image.

I take Alberti's reading—really, *mis*reading—of this passage to be definitive:

> I used to tell my friends [he says in the *De pictura*] that the inventor of painting, according to the poets, was Narcissus, who was turned into a flower; for, as painting is the flower of all the arts, so the tale of Narcissus fits our purpose perfectly. What is painting but the act of embracing by means of art the surface of the pool? (¶26)

The poets have said no such thing, so far as I can find. But Alberti wishes to locate a mythological origin for his own perspectival discourse—that is, of the three-dimensional world rendered into two. And Narcissus's erotic embrace of the image on the surface of the pool, purged rather improbably of all its negative elements, becomes the model. For me, in turn, it is the model for Ovid's own embrace, or co-optation, of the visual arts. Once Narcissus has been revealed to love a bodiless hope, the poem goes on to say, "adstupet ipse sibi vultuque inmotus eodem / haeret ut e Pario formatum marmore signum" (3.418–19; "He looks in speechless wonder at himself and hangs there motionless in the same expression, like a statue carved from Parian marble"). In this story so filled with iterative language—Echo's very identity on the one hand and Narcissus's endless grammatical reflexives on the other—this metamorphic moment of silence is one in which both of the identical parties to this love are works of art, one a statue, the other a painting.

Ovid's word for that marble statue is *signum*, which turns out to be as complicated and slippery as *imago*. By the time of

the *Metamorphoses* it is a perfectly ordinary word for statue—the metaphor having been developed at least two centuries earlier—but at the same time it carries a good deal of hermeneutic weight. When it refers to an actual statue, it carries a sense of the historic and semantic importance of sculpture. When it refers to individuals who have been transformed, the word retains all the punning doubleness of metamorphosis itself. Which is to say that Ovid seems to be announcing an act of signifying at the same moment that he announces metamorphosis. The term *signum* identifies the statue as the *imago* where narrative is frozen in metamorphosis. If Gian Biagio Conte is right in saying that "a literary text is a product whose interpretative destiny belongs to its own generative mechanism" (30), then one can say that the heritage of image-making, as well as the theorizing of narrative images in the fifteen hundred years following upon Ovid's lifetime, is merely the fulfillment of an inscribed destiny, the reciprocal consequence of a poetics that has attempted to annex pictoriality.

The story of the other hybrid—the composite painting that is also an analogical composite—is not a story about the authorial intentions of Zeuxis to shape or comment upon the relations between words and images. It is rather about the exemplary status that was accorded to his intentions, beginning with Cicero's *De inventione*, which tells this story at very notable length. The citizens of Croton (only Pliny places this story in Agrigento) pay a large fee to the artist so that he will decorate their temple of Juno. He decides that the subject should be Helen, "so that the portrait though silent and lifeless might embody the surpassing beauty of womanhood." The Crotonians are thrilled because Zeuxis has a great reputation as portraitist of female subjects. He asks them about beautiful girls in the town; they take him to the gymnasium and show him beautiful boys, suggesting that he extrapolate from the most

beautiful boys the beauty of their various sisters. "Please," he says, "send me then the most beautiful of these girls, while I am painting the picture that I have promised, so that the true beauty may be transferred from the living model to the mute likeness." The citizens assemble the greatest beauties and invite him to choose the loveliest one of all. But—and here we come at length to the gist—he chooses not one but *five*, because, as Cicero reports, Zeuxis "did not think all the qualities which he sought to combine in a portrayal of beauty could be found in one person" (2.1).

Perhaps the most important thing of all is the sheer surplus involved in telling the story as Cicero does, with narrative articulation out of all proportion to its immediate point. After several hundred words he finally arrives:

> In a similar fashion when the inclination arose in my mind to write a text-book of rhetoric, I did not set before myself some one model which I thought necessary to reproduce in all details, . . . but after collecting all the works on the subject I excerpted what seemed the most suitable precepts from each, and so culled the flower of many minds. (2.2)

In effect, all this art historical wind-up results in what seems a rather lame pitch—that is, to justify the unexceptionable practice of consulting multiple sources. What are we to think about the reasons for this surplus? Is Cicero implying that rhetorical performances themselves—and not just books about them—should be similarly composite? Does the painterly analogy signal Cicero's wish to arrive at *enargeia*, or to turn the rather unsexy matter of library research into the making of Helen of Troy? It is precisely the open-endedness of the Zeuxis story, including all of its supplementarity in the economies of the *De inventione*, that shapes its future possibilities. It

is a romance about the creation of a work of art, and it is an exemplum with a notable lack of precision or stability as to what it teaches. One thing is, however, always clear: it is a famous story about rhetoric that is a famous story about painting.

Zeuxis's picture of Helen offers a framework on which to hang every form of claim about discourse and visuality—and its opposite. The Zeuxis paradigm seems to promise an account (roughly Platonic) whereby the great artist copies and recombines and transcends nature all at the same time through some variously defined skill that stands outside the mere observation of nature and perhaps outside the faculty that chooses the pieces of nature it wishes to work upon. For the Renaissance art theorists who exploit the story—and they all *do*—Zeuxis has great authority but ends up being made to say whatever the writer wants him to say, often differing on precisely the most important message of the anecdote. Alberti uses the story to prove that painters should operate out of a complete fealty to nature rather than to their own *ingenium*. From Nature he slides to Beauty, "excellent parts [of which] should all be selected from the most beautiful bodies" (¶55). But he has had to elide all those things in nature that are *not* beautiful. The Zeuxis story helps him evade the contradictions, since faithfulness to nature among the maidens of Croton involves nothing but beauty.

Giovanni Francesco Pico della Mirandola flatly declares that "although [Zeuxis] had selected only five Crotonian girls celebrated for their beauty, nevertheless he did not put his faith even in these" (1:182) in comparison to some innate ideal. Later in the sixteenth century, Armenini confronts the issue by arguing that if Zeuxis did not have a *singolar maniera*, "he would never have been able to harmonize the beautiful individual parts he copied from so many virgins" (2.3). And Lodovico Dolce, extolling Raphael, faces up to the fact that

you can't really put together disparate parts without producing a disharmonious whole (the Horace fish-woman problem, which never gets forgotten in the art historical literature), so "if Zeuxis was able to make use of five different girls, who does not doubt that he added many excellent touches which were not found in any of them?" (5.172)—by which time the story has become almost a *lucus a non lucendo*, made to prove precisely the point that it was originally designed to disprove.

But I am really more interested in telling a constructive than a *de*constructive story, that is, in tracing the persistence of a canonical fable that gives individuals permission to theorize their own discursive or artistic activity along the fault lines of picture and word. It is, for example, no coincidence that Zeuxis forms the central, if implicit, example in a famous letter from Raphael-the-painter to Castiglione-the-writer:

> In order to paint a fair one, I should need to see several fair ones, with the proviso that Your Lordship will be with me to select the best. But as there is a shortage both of good judges and of beautiful women, I am making use of some sort of idea which comes into my mind. (33)

On the one hand, Raphael transmits the story perfectly when he focuses on the faculty of *judgment*, which he graciously ascribes to Castiglione. Here, in fact, he is playing quite directly off one of the most curious phrases in the Ciceronian narrative, about the poets who recorded the names of the five girls "because they were approved by the judgement of him who must have been the supreme judge of beauty" (2.1). Cicero the writer is paying deference to Zeuxis the artist, and Raphael is elaborately returning the compliment to Castiglione, who will correspondingly cite this sentence in the discussion of painting in the *Book of the Courtier*. But Raphael is also making space for something he seizes from the discursive realm

and annexes to his own personal genius: "una certa idea" that comes into his mind.

We can look to Leonardo for a far more combative stance, not only toward the other art but also toward the agendas of the story itself. The context is one of his favorite topics, the superiority of painters over poets:

> Something made by the poet may be likened to a beautiful face which is shown to you feature by feature, and, being made in this way, cannot ever satisfactorily convince you of its beauty, which alone resides in the divine proportionality of the said features in combination. (*Leonardo on Painting*, 36)

In the short run, Leonardo is making a simple point about the difference in temporality between verbal and visual art. But by defining poets precisely in the terms of the Zeuxis story, he exposes the essentially logocentric quality of this account of visual art. The dividing up of things into parts that are then recombinable as wholes is, in essence, discursive thinking. And in some sense the ongoing force of the Zeuxis story—its prescriptive force, that is, within the world of artistic theory and practice—is a kind of imposition by poets on painters.

Leonardo is sensitive not only to the shifting content of the tale but also to its means of transmission. He declares poets to be Zeuxis-like (i.e., makers of composites) not only because of the temporality of linguistic expression but also because of what we would call their interdisciplinary relations: "The poet," he says, "may be compared to those merchants at fairs who stock varied items made by different manufacturers. The poet does this when he borrows from other sciences, such as those of the orator, philosopher, cosmographer, and suchlike" (37–38). Leonardo has picked up Socrates's argument in the *Ion* against poets for having no *techne*

of their own. But in the diachronic context of the heritage of antiquity such a claim exposes the fundamentally logocentric quality of cultural transmission itself. Cicero had already exploited the linguistic advantage when he unpacked the analogy so as to document the difference between his own work and that of Zeuxis:

> He could choose from one city and from the group of girls who were alive at that time, but I was able to set out before me the store of wisdom of all who had written from the very beginning of instruction in rhetoric down to the present time. (2.2)

Writing, as Socrates recognized less positively in the *Phaedrus*, erases presence by crossing the bounds of geography and history. In contrast to these diachronic forces, the power of the visual artist is by implication placed outside the flow of time and difference. It takes the form of an inspired image, a perfect creation of beauty responsible only to an innate sense of proportion. It replicates neither history nor different discourses nor different phenomenological modules—in other words, it is not composite in the way of Zeuxis's *Helen*. So historical transmission itself is a kind of verbally constructed Zeuxis painting.

It is that combination of timelessness and historicity that the Zeuxis story in its most utopian form seems to promise. From the moment when Cicero makes the painter's act of representation into a paradigm for the operations of oratory, the tale invokes the possibility of rendering rhetoric visible and of rendering visuality rhetorical. When Giovanni Francesco Pico speaks of Cicero as "fashioning an image of the most beautiful body of eloquence" (1:172) or when Francis Bacon expresses the hope that a dictionary of all languages will create a composite language of the mind and thus produce a "fair Image of Speech" (6.1), they are conveying these longings.

When Castiglione not only cites the Zeuxis story but designs the whole technique of his book as the achievement of perfection by choosing and judging separate particles, he is attempting to make his words into what is—*almost*—a literal portrait. When Vasari narrates Raphael as an artist who created himself out of particles from Perugino, Leonardo, Fra Bartolommeo, and Michelangelo, he is rhetorically inventing an artist who is himself a work of art.

Something proverbially monstrous in one classical poem becomes the paragon of artistic beauty elsewhere. The destiny of pictoriality inside another classical poem is realized in whole galleries full of biform images. An ancient painting no one has ever seen becomes a prime site for picture theory and discourse analysis. Historical transmissions of these kinds do not just happen because everyone is perpetually on the lookout for *neat stuff*. The crossings between pagan and Christian, ancient and modern, visual and verbal are never easy—not just for reasons of theory but because they represent profoundly different ways of thinking, some of which are quite explicitly antagonistic to the others. In this instance, however, I believe we can locate the moment when this transmission was made possible, when art-language and poetry-language are reborn, chartered with the cachet of classical culture, and—perhaps most important—granted safe harbor (indeed enshrined) within Christian culture. That there is a modern language to talk about the visual arts, that such language is part of the humanist project, that imagistics and poetics are significant and interrelated subjects: all of this passes through a sequence of highly concentrated visual arts materials in the tenth, eleventh, and twelfth cantos of the *Purgatorio*. The terms in which Dante recuperates these materials and the contexts in which he sets them will be definitive of their future lives.

Within the space of these three cantos, which begin with Virgil telling Dante, "Qui si conviene usare un poco d'*arte*" (10.10; "Here must we use a little skill"), that last word chosen not by accident, we are treated to a trio of marble relief sculptures representing the Annunciation, King David, and the Emperor Trajan, all described in great detail; a simile in which a group of sinners is compared to corbel figures supporting a roof; a lengthy soliloquy by the manuscript illuminator Oderisi da Gubbio, who discusses his own work and that of other artists; a telling reference (the earliest we have) to the careers of Cimabue and Giotto; and finally another set of twelve narrative reliefs, divided among biblical and pagan subjects sculpted in the floor of the mountain. This nexus of references, often rendered in highly precise technical language, may represent the first extensive piece of writing on the visual arts of the modern era.

Much work has been done on the actual art objects that could have inspired Dante; and here, for once, such searches are worth undertaking, since the poet is not operating in a flourishing culture of rhetorical ekphrasis but boldly going where no man has gone for a thousand years. The pulpit reliefs of Nicola and Giovanni Pisano (figure 2.1) had opened the way for a new kind of visual affect; the Column of Trajan (figure 2.2) may have inspired not only specific art description but larger narrative structures of spiraling in the poem; and at least some of the images Dante describes were either common subjects in contemporary artwork, like the *Annunciation* (figure 2.3), or else commonly believed to be represented in surviving ancient art, like the story of the Trajan and the Supplicating Widow (figure 2.4), mistakenly believed to be represented on Trajan's Column, though the subject was in fact the province of Dacia accepting defeat.

2.1

Nicola Pisano,
Crucifixion, pulpit
relief (ca. 1260).
Duomo, Siena.
(Scala/Art
Resource, NY.)

But the real story is not that Dante could find existing art works to inspire him; rather it is the fact that he could invent, or reinvent, the language in which to talk about that inspiration. At every stage, this account of the visual arts transmits a sophisticated understanding of all the issues of visuality, representation, and language that antiquity would offer to the moderns. He uses a number of very technical terms, for example, *intaglio*, *imposta*, *effigiata*, that seem to have existed previously only in the professional languages of visual artists and subsequently gained wider diffusion. He follows throughout these cantos a remarkably detailed subplot devoted to the physical mechanisms of scrutinizing representational art objects: looking left, right, and down; proceeding sequentially in the narrow space; moving from long shots to close-ups; needing to concentrate the eyesight so as to disentangle what one

sees; experiencing the ocular or mental disorientation of the switch from representational reliefs to real people.

So far as his own poetic purposes are concerned, Dante seizes upon and moralizes the traditional structural place of ekphrasis inside epics—that is, as a moment of stasis inside a larger dynamic *telos*—so as to moralize the pilgrim's own problematic of contemplation and action as he moves upward in his journey. In the process, he reveals an acute aware-

2.2
Column of Trajan,
general view.
Rome. (Scala/Art
Resource, NY.)

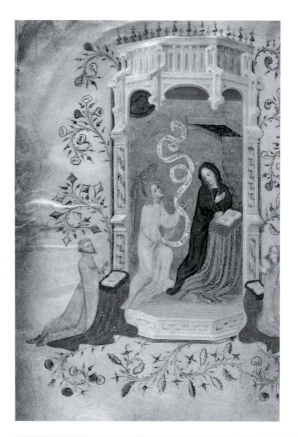

2.3
Annunciation,
in the Beaufort/
Beauchamp Hours
(early fifteenth cen-
tury). British Library.
(British Library Board,
Royal 2 A XVIII f.23v.)

2.4
Province of Dacia
accepting defeat, detail
from Trajan's Column,
Rome. (Photograph
courtesy of Peter
Rockwell.)

ness of the temporality problem that separates visual from verbal narrative. It is no accident that the pilgrim loses track of time in looking at the floor reliefs. Nor should it be a surprise that at the moment when the first ekphrasis gives way to a "real-life" procession of sinners the poet's voice warns the reader, "Non attender la forma del martìre: / Pensa la succession" (10.109–10: "Heed not the form of the pain: think what follows"); this *martire* is partly the poem's own moving picture but partly the frozen image of a saint's martyrdom that needs to be narratized in the larger time frame of salvation. The image by itself, in other words, fails to give a complete picture of the *succession*.

But the most powerful and prophetic of the ways Dante manipulates pictoriality poetically appears in his attempt to frame the presence of language in the image. The triptych of narrative reliefs in canto 10 is really a study in the inextricability of what is seen and what is spoken. "Non sembiava imagine che tace" (10.39; "it seemed not a silent image"), says the poet to begin with; and then he proceeds to reinvent the cliché. He is referring to the annunciating angel:

> Giurato si saria ch'el dicesse "*Ave!*";
>> perché iv' era imaginata quella
>> ch'ad aprir l'alto amor volse la chiave;
> e avea in atto impressa esta favella
>> "*Ecce ancilla Deï*," propriamente
>> come figura in cera si suggella. (10.40–45)

One would have sworn that he was saying, "*Ave*," for there she was imaged who turned the key to open the supreme love, and these words were imprinted in her attitude: "*Ecce ancilla Deï*," as expressly as a figure is stamped on wax.

Every term that is meant to convey how the image speaks is radically ambiguous. If, as has sometimes been argued, the real-life artwork underlying this description is the kind with scrolls or cartoon balloons including the quoted expressions (see figure 2.3)—further complicated by the possibility of a *boustrophedon* reading of "Ave" as "Eva"—then Dante is teasing us all the more by his transformation of a familiar word-image hybrid into a paradoxical mystery. To say that this speech was imprinted on her body position would not appear to suggest the literal presence of writing. But what *does* it suggest? The clarification— "propriamente / come figura in cera si suggella"—renders the matter exquisitely moot: as an analogy for the presence of language, the poet draws on the mechanisms of producing an image, except that this image that is produced in wax is a *figura*, the punningest term in the whole lexicon of language and picture.

The succeeding two ekphrases entangle word and image as well: the scene of David and Michal appears to produce sense experiences of hearing and smelling, while the episode of Trajan and the Widow generates a whole imagined dialogue. For all that, it's important to recall that it is not Dante's purpose per se to reinvent artistic terminology or theorize the visual and the verbal. In this part of the approach to Purgatory it is the prideful who are being chastened. Visual representation is not merely the medium in which pride is depicted; it is in itself a metaphor for pride. That is why we find the illuminator Oderisi da Gubbio in this company and more particularly why his problem is competitiveness. He calls it "lo gran disio / dell'eccellenza" (11.86–87; "the great desire for excellence"); but we ought to notice that he is still fussing over the superior achievement of his colleague Franco Bolognese. (Clearly, Oderisi is about halfway to purgation, since in response to Dante's praise he courteously declares that the honor now all

belongs to Franco, to which he adds, "e mio in parte." Whoever is supposed to win, Oderisi still has his eyes on the contest.) In a similar vein is Oderisi's own famous estimate of two other artists:

> Credette Cimabue ne la pittura
>> tener lo campo, e ora ha Giotto il grido,
>> sì che la fama di colui è scura. (11.94–96)

> Cimabue thought to hold the field in painting, and now
> Giotto holds the cry, so that the other's fame is dim.

The importance of these lines to art history tends to make us forget that they have nothing to do with the quality of the two artists but only with how trendy they are. And they give rise to a rather special form of *sic transit gloria mundi*, almost blasphemous in so eschatological poem as the *Commedia*, where the fragility of earthly achievement ought to be measured by death and the afterlife rather than by the changing hemlines of next year's artistic fashions. (It is worth remembering that, at least at the fictional time of the journey, both Cimabue and Giotto are alive and productive.) It is, by a similar logic, appropriate that the sin of these cantos is so often described as some form of novelty, including the pilgrim's own slightly excessive interest in the pictures. Historically, the plastic arts of the *trecento* were—and understood themselves as—something new; and anything that succeeds because it is new has the potential to fail at the arrival of something newer.

Now the competitiveness of artists or of the art market might be a sort of sidebar in the depiction of pride but for the problematic of mimesis, to which we must return. The imitative arts are by definition competitive. Competition among artists sits in parallel relation to competition between the arts: after all, Socrates showed us that poetry owes its very

definition to the nexus of mimesis, comparison, and competition. Oderisi follows the case of Cimabue and Giotto with the slightly closer-to-home examples of the two poets Guido Guinizzelli and Guido Cavalcanti, also characterized in terms of the vagaries of fashion—only they are both threatened by an unnamed successor who will get rid of both of them. This is not merely a jokey piece of auto-irony: Dante is writing himself into the rolls of the prideful, albeit the curably prideful. More to the point, he is using the border territory of the arts, for which he has produced a reinvented language, to explore the linguistic and sensuous problematics of poetic mimesis. Hence the strong thread of poetic self-consciousness in these visual arts cantos, and the implicit but unmistakable message that *visibile parlar*—visible speech—is what his poem itself is achieving.

But that expression is keyed to a different poet:

Colui che mai non vide cosa nova
 produsse esto visibile parlare,
 novello a noi perché qui non si trova. (10.94–96)

He who never beheld any new thing wrought this visible speech, new to us because here it is not found.

The novelty that runs through these cantos, whether it applies to the illuminators, the painters, or, for that matter, the *dolce stil novo*, receives its comeuppance here in the face of a universe where nothing can ever be new. That is, *mutatis* one important *mutandis*, precisely the universe out of which was born the very tangled definition of poet and painter with which I began—in other words, the place of transcendent forms, from which all imitations derive and define.

Obviously, Plato is one thing and the Christian God another; and yet the very opening of this whole segment of the

poem, the *terminus a quo* of the art language, points precisely to the Socratic declension. On the sharp incline along the sides of the mountain we see the terraces

> di marmo candido e addorno
> d'intagli sì, che non pur Policreto,
> ma la natura lì avrebbe scorno. (10.31-33)

> Of pure white marble, and adorned with such carvings that not only Polyclitus but nature herself would there be put to shame.

Polyclitus—Nature—God: the ladder that climbs upward still keeps its lowest rungs intact. Dante is fusing a Platonically inflected Christian tradition, principally from Augustine, to a professional language of the visual arts that had already been anciently entwined with poetics. Augustine had proposed a *deus artifex*; he had also outlined the laws of Christian hermeneutics to be applied to God's parables, which he described as *verba visibilia*. Relevant as well is the enormously influential pronouncement by Pope Gregory I at the beginning of the seventh century:

> A picture is displayed in churches in order that those who do not know letters may at least read by seeing on the walls what they are unable to read in books. . . . What writing offers to those who read it, a picture offers to the ignorant who look at it . . . , [for whom] a picture stands in the place of reading. (Letter to Bishop Serenus)

This means of justifying Christian visual representations with a formula that yoked the reading of words by the learned to the viewing of pictures by the illiterate depended on extracting the doctrinal *historia* from mere visual sense experience. It is from that source, via Dante's constant use of the word *storia*

in reference to his ekphrastic images, that it will become the purified humanistic term for visual narrative. But Dante also adds the full armature of a technical language of the arts: in effect, through this remarkable passage *deus artifex* has become the professional modern artist as a kind of god.

But it is the entire sequence, from Polyclitus early in canto 10 to the twelve floor-reliefs in canto 12, that creates the wholesale importation of art language into the formulas of poetics. Looking back on that latter set of reliefs, the poet concludes:

> Qual di pennel fu maestro o di stile
> > che ritraesse l'ombre e 'tratti ch' ivi
> > mirar farieno uno ingegno sottile?
> Morti li morti e i vivi parean vivi:
> > non vide mei di me chi vide il vero,
> > quant' io calcai, fin che chinato givi. (12.64–69)

> What master was he of brush or of pencil who drew the forms and lineaments which there would make every subtle genius wonder? Dead the dead, and the living seemed alive. He who saw the reality of all I trod upon, while I went bent down, saw not better than I.

Once again, the comparative/competitive mode. The passage concentrates the official terminology of the visual arts—*pennello, stile, ingegno*—but frames it in the analogical context of poetic mimesis. If at the beginning of this segment, Polyclitus was a poor third, here Dante, poet or pilgrim, is a close second, even if he has to bend over to see his represented version while "chi vide il vero" ("whoever saw the true": God? Virgil? spectators of the real-life events?—again, the Socratic declension from the transcendent to the material to the mimetic) gets to experience it upright. The extraordinary formula *morti li morti e*

i vivi parean vivi, while obviously applying to the work of the divine artist in the reliefs, is also an auto-compliment paid to the *Commedia* itself. On the one hand, it is the newest version of all those clichés about things visually represented being not mere pictures but real or alive; on the other, it is a quite acute description of the special case of Dante's poem, in which all (with one exception) are dead but are made seemingly alive—*parean vivi*—not through the work of God the artist but through that of Dante the poet. Even that ingenuous little *parean* (seemed) which gently disturbs the perfect parallel is telling: the dead are really dead, while the living are created alive by art.

When Benvenuto da Imola, as early as the 1370s, glosses the lines asking "What master was he of brush or pencil . . . ?" he takes the extraordinary step of offering Apelles, Zeuxis, and Phidias as possible answers to the rhetorical question. When he comes to *morti li morti*, he declares that it is just like what Pliny says about a particular triumph of Apelles:

> There is, or was, a picture of a Horse by him, painted in a competition, by which he carried his appeal for judgment from mankind to the dumb quadrupeds; for perceiving that his rivals were getting the better of him by intrigue, he had some horses brought and showed them their pictures one by one; and the horses only began to neigh when they saw the horse painted by Apelles; and this always happened subsequently, showing it to be a sound test of artistic skill. (Pliny, 35.25)

That it was possible, however tentatively, to cross from the sacred, poetical, and divinely produced images on the mountain of Purgatory to the ancient history of art (subspecialty equine graphics) signals the entry of Dante's visible speech into the painterly humanism of the Renaissance. And by the end of the fourteenth century, roughly contemporaneous with Ben-

fu douel mente moietto si mma.
o stancato 7 amendue mcerti
di notha uia ni tenuno si nun piano
solingo piu che strade p disert.
Dela sua sponda one confinal nano
apie delatta ripa che pur sale
mi su riebte mtre notre un corpo humao.
Quanto laceuno mo potea narrale
leia cass mstro shoz dal cestro stanco
questa cornice nu parei cotale.
La su non cam moss i pic mi anco

acoio che susse allacchi mici dispolta.
Era mtagliato li nel marmo stess
lo carro 7 buoi castendo lama sai
pche si cenie officio non comello.
Dinanci parea genie 7 tucta quim
partita in sette chou none mie sensi
sica duar lun no lauri canti.
Simile mente al summo collmcenst
che uen ymaginato ivechi el naso
7 al su salno discordi sensi.
I proceduca il benedecto uaso

venuto, manuscript illuminations of this episode begin to ap-
pear, which are among the first pictures of people looking at
pictures (figure 2.5).

It will be quite precisely the phrase about the living and
the dead that leads the way from God's art to that of human
beings. Only slightly disguised, Dante's poetic *de*scription will
become artistic *pre*scription in Alberti's *De pictura*:

> They praise a "historia" in Rome, in which the dead Me-
> leager is being carried away [figure 2.6]. . . . In the dead
> man there is no member that does not seem completely
> lifeless; they all hang loose; hands, fingers, neck, all
> droop inertly down, all combine together to represent
> death. . . . So in every painting the principle should be

observed that . . . not even the smallest limb fails to play its appropriate part, that the members of the dead appear dead down to the smallest detail, and those of the living completely alive. (¶36)

And, a hundred years later, in Vasari, the same Dantean line reverts to *de*scription, not of a poetic picture but of a real one:

He returned to his labour, and, working at it continually, he carried it to perfect completion in a few months, giving such force to the paintings in the work that he justified the words of Dante

Morti li morti, i vivi parean vivi.

And here also may be seen the misery of the damned and the joy of the blessed. (2:692)

2.6

Meleager Sarcophagus. Archaeological Museum, Istanbul, Turkey (Vanni / Art Resource, NY.)

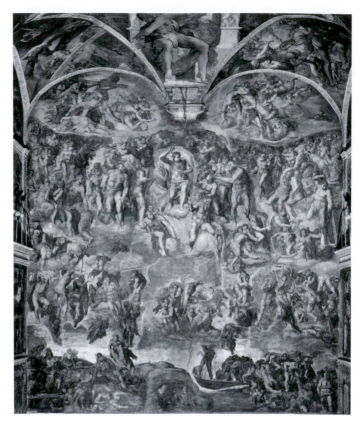

2.7

Michelangelo,

Last Judgment, general

view (1536–41).

Sistine Chapel, Vatican

Palace, Rome. (Scala/

Art Resource, NY.)

The subject is, of course, the making of Michelangelo's *Last Judgment* (figure 2.7). The link between the equally culture-defining figures of the thirteenth-century poet and the sixteenth-century artist can represent one particular instantiation of word-and-image as enacted in early modern culture. And if the issue upon which they are here joined—the giving of life to dead matter—seems to embody the fundamental enterprise of mimesis, it appears that all of Socrates's anxieties were fully justified.

Desire *and Loss*

Another, possibly wayward reminiscence. Long ago, when I imagined a future as a composer, I was being tested for the possibility that I might skip the elementary course in music theory and proceed directly to the advanced section. The professor seated me on the bench in front of his frighteningly large grand piano and began the examination by asking me to define a diminished seventh chord. When I responded by saying that it was three minor thirds strung together, he threw up his hands and declared that that was like saying that a face was an eye, a nose, a mouth, and a second eye. In other words, I had enumerated the constituent parts of the object in question but conveyed nothing concerning its fundamental nature or its place in the scheme of things. I cannot now remember the correct answer about the diminished seventh, and I remain grateful to have failed this test, considering the bitter recognition of incompetence I eventually endured even among the music theory beginners. But what I really learned from the experience—for which much thanks to the extraor-

dinary Claudio Spies—was the difference between describing something and attempting to account for it.

That "attempting" deserves special notice. If, back in college, I was quick to add up those minor thirds and yet clueless in regard to a more deep-structural answer, it's because, in music theory or elsewhere, description is a great deal easier to produce and easier to agree upon than the kind of analysis that posits underlying causes and relations. So, considering that this anecdote is meant to signal the transition in the present volume from something more like taxonomy toward something more like diagnosis, I should also be warning the reader that we are now going to ratchet up the level of speculativeness and free association, beginning with two pieces of Hellenic culture: a canon of beauty and a canon of ugliness. The first is an artwork, the second a text; but, inevitably, the discussions of each medium will be contaminated by the other.

By general scholarly agreement, the *Cnidian Aphrodite* was the first colossal female nude in the history of Western sculpture (figure 3.1). But the statue is not merely naked. That Aphrodite wears no clothes is only the beginning of the revolution here. The choice of depicting her nude derives its power and meaning, to begin with, from the fact that she is holding a wad of drapery that *could* cover her if only she were not brandishing it at a distance. Then, balancing her rounded form, is a correspondingly sensuous artificial structure, the jug, that is being lavished with a surplus of covering—unnecessarily, since jugs have no modesty. The outstretched fabric is perfectly poised in relation to the goddess's exposed parts, which could revert to their traditional secret positioning with a mere turning of her arm; but the placement of the strut, which may or may not have been part of the Praxitelean original, seems definitively to disallow this potential act of *pudeur*. Aphrodite's nakedness, in other words, is staged in the imminent

3.1
After Praxiteles,
Cnidian Aphrodite.
Museo Pio
Clementino,
Vatican Museums,
Rome. (Vanni/Art
Resource, NY.)

presence of its opposites. A further theatricalization of the figure's display is offered by her posture, which seems to locate an observer, or even an intruder, to her left, as distinct from a "real" full-frontal observer, thus already inspiring a voyeuristic narrative.

The astonishingly equivocal gesture of her right hand takes these motifs of problematic observation even further. Does it conceal or emphasize the genital area? Does it speak to the vulnerability of the figure, or to the source of her power? What is certain is that it captures the visible and the invisible—there are those terms again—in a tangle of ambiguity. Aphrodite's hand atop a pubic region that itself appears to be undeveloped is like the famous curtain in Pliny's story about the Parrhasius painting that fooled his rival Zeuxis. It appears to be a cover, but if you look under it, all you end up observing is your susceptibility to the trickery of art; you've been caught peeping, and there's nothing there. Parrhasius, said Pliny in another context, followed the dictum that the artist should "ostendat etiam quae occultat" (35.68; "disclose even what he hides"). The same goes for Aphrodite, and for her maker Praxiteles.

And for an entire tradition. The *Cnidia* gives rise to a whole descendancy of female nudes, many of which, as it happens, have played a significant role in the continuing imaginative life of classical statuary from the Renaissance onward. The *Medici Venus* (figure 3.2), famous from the seventeenth century when it was placed in the Uffizi Tribuna, where it remains, makes it clear—or, at the very least, its restorations do—that the Cnidian original's gesture of sexual concealment/emphasis was a decisive feature: why merely cover one private region when you can cover two? The equally famous *Capitoline Venus* (figure 3.3) (whose arms are not restored but original), contemporary and Roman competitor of the Florentine work, includes the Praxitelean jug and garment, even though they have less

3.2

Medici Venus.
Uffizi, Florence.
(Alinari/Art Resource,
NY.)

3.3

Capitoline Venus.
Musei Capitolini,
Rome. (Scala/Art
Resource, NY.)

logic and sensual effect when the goddess's hands are not free
to integrate them. Another statue that sometimes goes by the
name *Venus Victrix*, also a seventeenth-century import to the
Uffizi, restores logic by maintaining the double *pudica* gesture

3.4.

Venus Felix. Museo Pio
Clementino, Vatican
Museums, Rome.
(Scala/Art Resource,
NY.)

but locating the garment—uselessly, from the point of view of
concealment—around the back of the body. And the *Venus
Felix* (figure 3.4), which had found its way to the pope's Bel-
vedere courtyard by the early sixteenth century, completes
the narrative of drapery and modesty by returning the cloth

80

to its Praxitelean position on the statue's left but attaching it to the right hand, where it augments the familiar gesture of protecting the figure's genital region. With all these possible variants—and with more distant relatives, whether they are standing, bathing, crouching, washing their hair, adjusting their sandals, or emerging from the waves—these are figures that, quite literally, canonize the female nude as a preeminent subject for artistic expression.

But canon is itself a discursive subject, with which we stray into the realm of language, wherein, as it happens, the *Cnidia* occupies quite a bit of space. "They say," Pliny the Elder tells us in his discussion of this same sculpture, "that a certain man was once overcome with love for the statue and that, after he had hidden himself [in the shrine] during the nighttime, he embraced it and that it thus bears a stain, an indication of his lust" (36.21). A couple of centuries later, the Lucianic author of the *Erotes* turns this event into a full-blown romance. The lover would spend his whole day in Aphrodite's shrine, in an appearance of religious piety while in fact murmuring secret love chat to her. He played games of chance in the hopes of getting lucky. He wrote amorous messages all over the walls of the temple and on the bark of trees (shades of Mad Orlando). He started worshipping Praxiteles as much as Zeus. Finally one evening when the temple was about to be closed,

> quietly and unnoticed by those present, he slipped in behind the door and, standing invisible in the inmost part of the chamber, he kept still, hardly even breathing. When the attendants closed the door from the outside in the normal way, this new Anchises was locked in. But why do I chatter on and tell you in every detail the reckless deed of that unmentionable night? These marks of his amorous embraces were seen after day came and the

goddess had that blemish to prove what she'd suffered. The youth concerned is said, according to a popular story told, to have hurled himself over a cliff or down into the waves of the sea and to have vanished utterly. (*Erotes* 16)

The youth vanishes; the story, as we shall see, does not.

In one form or another the tale of the amorous stain is to be found *passim* in the ongoing mythology of art, especially sculpture. Just in the immediate Plinian context, and regarding the same sculptor, we have the *Eros of Parion*, which (I again quote the *Natural History*) "is equal to the Aphrodite at Knidos, both for its fame and for the injury it suffered; for Alketas the Rhodian fell in love with it and also left upon it the same sort of trace of his love" (36.22). At least in regard to male desire, then, it is an equal opportunity story, offering both homo- and heterosexual possibilities. Clement of Alexandria offers up a whole sequence of pagan sexual enormities committed upon artworks (*Exhortation* 3). Athenaeus in his *Deipnosophistae* produces several instances of men who got up-close and personal with sculpture. A delegate to a Delphic festival left a wreath in payment for the pleasure he took with the statue of a boy; apparently, his effort was more successful than that attempted by Cleisophus of Selymbria, who,

> becoming enamoured of the statue in Parian marble at Samos, locked himself up in the temple, thinking he should be able to have intercourse with it; and since he found that impossible on account of the frigidity and resistance of the stone, he then and there desisted from that desire and placing before himself a small piece of flesh he consorted with that. (13.605)

Even in Rome, where we might expect more decorous behavior, we learn from Varro (via Pliny) that the knight Junius

Pisciculus fell in love with one of the Muses sculpted on the Temple of Felicity, possibly also by Praxiteles (36.39). And, in an anecdote as sinister as it is revealing, Pliny explains how the dissipated emperor Tiberius caused Lysippus's statue of the *Apoxyomenos* (figure 3.5), or the Boy Scrubbing himself with a Strigil, to be taken out of public space and transferred to his

3.5
After Lysippus, *Apoxyomenos*. Museo Pio Clementino, Vatican Museums, Rome. (Universal Images Group/Art Resource, NY.)

own bedroom; only when the Roman populace clamorously demanded its return was the emperor prevailed upon to restore the statue, *quamquam adamatum*—despite how much he had fallen in love with it (34.62).

How are we to comprehend this strand in the history of art appreciation? One approach is to consider these anecdotes as chapters in the history of abnormal psychology—a Kraft-Ebbing of aesthetics. For Athenaeus, sex with statues belongs in a catalogue of perversions that includes military rape and a rooster falling in love with a sommelier, while the exploits of Tiberius are by definition deviant. We are talking, in other words, about a territory that, depending on different cultural definitions of unorthodox sexual practices, connects the experience of art to activities understood as bestiality, sodomy, and masturbation.

The *Aphrodite*, however, develops a broader range of associations. In another story about her (36.20–21), Pliny tells us that Praxiteles produced two versions, one clothed and the other nude. Given the option of either piece, the people from the city of Cos chose the clothed Aphrodite, leaving the Cnidians with only the naked version of the goddess that remained unsold in the showroom. The benighted citizens of Cos, wishing to act in a manner that is *casta* and *severa*, choose the Aphrodite that is, by virtue of her clothing, *casta* and *severa*. The joke is on them: their statue and their town are virtually forgotten, while the Cnidians, forced to purchase the more sexually explicit reject, find themselves in possession of the most admired art object in the world. Pliny also reports that King Nicomedes was so eager to buy the *Aphrodite* from the Cnidians that he proposed to pay off the city's entire vast public debt in return. The citizens refused his offer, however, and they were right to do so, because the statue has become world famous, and it has put their city on the map. Whatever

3.6
Titian, *Sacred and Profane Love* (1515). Galleria Borghese, Rome. (Alinari/Art Resource, NY.)

the truth of these tales, they act as counterpoint by placing a value on nudity—aesthetic, economic, political—that may be distinguished from the pure objectification of desire that the story of the stain is meant to convey.

And these complications have a considerable life beyond Praxiteles. They take us both backward in time, to the variously interpreted twin Aphrodites of Plato's *Symposium*, and also in the other direction, toward the equally complicated dualities of Titian's so-called *Sacred and Profane Love* (figure 3.6) (not that he gave it that name, exactly), which seems to be confronting the Plinian duality quite literally. It seems that, whether the artist is Praxiteles or Titian, the opposition between clothed and naked becomes the aesthetic equivalent of the philosophical or theological opposition between earthly and heavenly—except that it may not be obvious which pair belongs together. Hence the more otherworldly qualities of the figure on the right of Titian's painting. And hence the error of those poor benighted citizens from Cos, who go wrong in failing to recognize that the rules of art are different from, indeed perhaps opposite to, the rules of life. On the

scale of citizenship, you may be well advised to admit clothed ladies rather than naked ones into your town, but on the scale of art, it is nudity and not civic decorum that is liable to produce ultimate value. We shall return to the *Aphrodite*; for the moment, though, let us say provisionally that when writers tell stories about artworks, it may be for the purpose of locating them as objects of desire.

Let us now turn to our canon for ugliness, which finds its essential expression in a quite perplexing set of formulations near the beginning of Aristotle's *Poetics*:

> It can be seen that poetry was broadly engendered by a pair of causes, both natural. For it is an instinct of human beings, from childhood, to engage in mimesis (indeed, this distinguishes them from other animals: man is the most mimetic of all, and it is through mimesis that he develops his earliest understanding): and equally natural that everyone enjoys mimetic objects. A common occurrence indicates this: we enjoy contemplating the most precise images of things whose actual sight is painful to us, such as the forms of the vilest animals and of corpses. The explanation of this too is that understanding gives great pleasure not only to philosophers but likewise to others too, though the latter have a smaller share in it. This is why people enjoy looking at images, because through contemplating them it comes about that they understand and infer what each element means, for instance that "this person is so-and-so." For, if one happens not to have seen the subject before, the image will not give pleasure *qua* mimesis but because of its execution or colour, or for some other such reason. (1448B)

In part, this is territory that has been well covered in these pages. Whatever it is that Aristotle wants to say about poetry,

he apparently can*not* say without shifting his field of reference to pictures. More specifically, the difference he wishes to posit between real things and imaginary ones—which is the point of the whole argument—will not be sufficiently persuasive if the imaginary things take the form of texts rather than images.

So far as the substance of that argument is concerned, there are a number of indications that the claim about those vile animals and corpses, the sight of which in reality would be repellent but whose appearance in the form of εἰκόνες gives pleasure, involves Aristotle in what is even for him problematic territory. It's not surprising, for instance, that in *On the Parts of Animals* the notion of ugly nature and beautiful art would have to be considered differently: "Surely it would be unreasonable, even absurd," he says, "for us to enjoy studying likenesses of animals—on the ground that we are at the same time studying the art, such as painting or sculpture, that made them—while *not* prizing even more the study of things constituted by nature" (645A). And in the *Politics* he reorders the art-and-nature priorities in yet a different way: "The habit of feeling pleasure or pain at mere representations is not far removed from the same feeling about realities; for example, if anyone delights in the sight of a statue for its beauty only, it necessarily follows that the sight of the original will be pleasant to him" (8.5).

What these alternative formulations, almost contradictory to the passage in the *Poetics*, demonstrate is that the proposition there about corpses and vile beasts is radical and unstable. The claims in both the *Parts of Animals* and the *Politics* texts are far more sensible than those in the *Poetics*: why should we value the compositions of art more than the compositions of nature? (Certainly, Socrates didn't.) Isn't it more impressive that nature could produce a real beast than that an artist could produce a fake beast? And does it make any sense that

we would go into raptures about a portrait and yet be indifferent to the visual effect of the real person who was being portrayed? The answer takes us back to the people from Cos and the people from Cnidos: if you're talking about politics or zoology, the real is going to stand in definitively higher place than the fabricated; if you're talking about art, however, the priorities may get reversed.

The reason for this edgy formulation, which gets contradicted by Aristotle's more commonsensical claims elsewhere, has, once again, to do with *mimesis*. In effecting a translation between the actual and the mimetic, Aristotle postulates a concept of recognition, variously expressed with the verbs μανθάνειν and συλλογίζεσθαι, conveying notions of *inference* and *reasoning together*. He takes pains to suggest that there is a lofty version of this activity, which is the province of philosophers. But he is less explicit about that higher form of recognition than he is about the more ordinary procedure, which is itself divided between the simple case of being able to identify an individual in a picture because one has previously seen that individual in real life, or, if one hasn't seen the individual, merely deriving one's pleasure from the skill or colorfulness or finish in the representation. Meaning, presumably, that the philosopher's kind of recognition transcends either the mere exercise of putting a name to a face or—what is by implication even lower on the scale of mimetic experiences—the sensation of being titillated by the artistic flourishes. The philosopher, in short, has more to say than, "By Zeus, that's an asp!" or, alternatively, "What a lovely shade of puce on that unidentifiable blob!"

Which is the reason for the snakes and corpses. The action of recognizing a portrait of Uncle Demetrios or else of delighting in the painterly impasto on a landscape that we fail to identify does not depend in any way on the picture representing something whose reality would be repellent. So

the philosopher's part in all this is the ugliness part. And in particular it has to do with the transit from ugliness to pleasure. Now the import of the whole passage may be somewhat more clearly plotted. In three simple propositions, Aristotle here quietly delivers a series of devastating blows to Platonic claims according to which art is fundamentally epiphenomenal and dangerous in its relation to reality. First, mimesis is innate: indeed, it is the very language of infancy and the means of becoming human. Second, mimesis is pleasurable, both in the performance and in the recognition. Third, mimesis is legitimately transformative: it creates a delight whose sources are independent of, and even contradictory to, reality; thus it functions as some kind of autonomous state.

Which takes us to the larger question of why we have εἰκόνες at all. After all, Aristotle is not really interested in the visual arts, just as Socrates is not trying to banish painters from the Republic and just as Horace is not really writing art criticism about a woman-fish portrait. The truth of the matter, as we have seen throughout these pages, is that, if the subject is really poetics, we have to face the fact that words-for-things do not relate to things in the same way that pictures-of-things relate to things. But Aristotle's invocation of ugliness may help us disentangle these matters. Granted that between delighting in a sculpted snake and watching *Oedipus Rex*, only a very jagged—and perhaps even misleading—set of equivalences operates. But the choice of those repellent comparanda should tip us off that Aristotle is addressing the same question that A. D. Nuttall so charmingly pondered in his little book under the title *Why Does Tragedy Give Pleasure*?

But before we get to tragedy, we should note that, just as the *Aphrodite* has a descendancy in the visual arts (as well as in text), so do Aristotle's snakes and corpses. Later antiquity—admittedly, considerably later than the *Poetics*—witnesses an

enormous fashion for the representation of figures that, while not exactly vile beasts and dead bodies, are decidedly unidealized and unbeautiful. Statues like the Munich *Drunken Old Woman* (figure 3.7) or the Terme *Boxer* (figure 3.8) exist in sufficient profusion and possess sufficient refinement of technique such that we have every reason to feel that they were objects of connoisseurship. We have already heard Pliny's anecdote about the aesthetically challenged Teuton ambassa-

3.7
Drunken Old Woman.
Glyptothek, Staatliche
Antikensammlung,
Munich. (Vanni/Art
Resource, NY.)

dor who is unimpressed by the statue of an old shepherd because he wouldn't even want a *real* old shepherd in his house. Clearly, he has not been reading his Aristotle, and, just as clearly, Pliny expects his readers to be precisely on the wavelength of that passage in the *Poetics*, suggesting that mimesis

3.8
Terme Boxer.
Museo Nazionale
Romano, Rome.
(Scala/Art
Resource, NY.)

produces the greatest pleasure of all when it inspires the longest arc between the thing represented and the representation.

My own particular canon of ugliness follows the historical trajectory from ancient Roman collecting to early modern collecting to the production of new art. Renaissance aesthetics is ablaze with ugly beauties, monsters both physical and moral, which produce delights that range from Grand Guignol to the loftiest forms of connoisseurship. Vasari recounts how Leonardo designs a horror coat-of-arms for a presumptuous peasant by collecting in his own private room

> lizards great and small, crickets, serpents, butterflies, grasshoppers, bats, and other strange kinds of suchlike animals, out of the number of which, variously put together, he formed a great ugly creature, most horrible and terrifying, which emitted a poisonous breath and turned the air to flame. (1:629)

In one of the innumerable Renaissance jokes on Zeuxis and the composite painting of Helen, Vasari has Leonardo exercise his genius by taking ugly reality and turning it into magnificent invention. He designs the object as a Shield of Medusa— the quintessential painting that freezes the observer in horror. And so it does, at first: Leonardo's father is terrified when the artist has staged the piece in full Medusa regalia. But as soon as the viewer realizes that these are not real-life monsters but imaginative designs—in effect, that they have been transformed by the Zeuxis principle of composite invention—then the picture becomes a *capriccioso discorso*, a witty conversation (in effect, a collection of *words*). Vasari goes on to nail this down as an instance of pure aesthetic experience when he has Leonardo lose all interest in the work after it has produced its *coup de théâtre*, declaring, "This work serves the end for which it was made; take it, then, and carry it away" (1:629).

92

In another chapter of the *Lives*, when Vasari reports on Piero di Cosimo's grisly Masque of Death, he theorizes the delight that it produces. The Masque was not

> pleasing through its beauty, but, on the contrary, on account of a strange, horrible, and unexpected invention, [it] gave no little satisfaction to the people: for even as in the matter of food bitter things sometimes give marvelous delight to the human palate, so do horrible things in such pastimes, if only they be carried out with judgment and art; which is evident in the representation of tragedies. (1:653)

Back to tragedy and to what has become *ut poesis pictura*: Vasari turns the analogy around, now exploiting the properties of text as a way of theorizing picture. Everyone knows that tragedy is an art form that is enthusiastically embraced despite its painful contents; by that association, he proposes that visual art as well has the right to be ugly or (indeed, in the mode of Horace's much quoted sentence about the liberties of poets and painters) to represent that which could never be seen in the world.

Into this fairly traditional set of materials, Vasari somewhat surprises us by his reference to food, whose analogical force ought to inspire the same sorts of questions we have asked about the utility of pictures in an account of poetry. Vasari—let us say in particular because he has been brought up on Tuscan cuisine—takes it as a given that bitter tastes might *seem* unwelcome but are in fact deeply satisfying; they are, in short, the equivalent of Aristotle's snakes and corpses. By moving from Piero di Cosimo in one direction toward tragedies and in the other direction toward, let us say, *cicoria*, Vasari is mapping out the gamut from bodily sensation at one end to the loftiest intellectual satisfactions at the other end—all of which is placed under the aegis of pleasure.

And that is really the territory for word and image. An artist has—for reasons that are lost to history, as indeed the work itself is lost to history, though preserved in strikingly varying replicas—made a set of creative choices, and a whole descendancy of writers has responded to them. It's a little like *skiagraphia*: a material practice in the workshop that gets subsequently exploited by writers as a trope. In this case, the subject has to do with desire. Whereas in the *Republic* mimesis was a set of mechanisms, and untrustworthy ones at that, for Aristotle it is a fundamental—indeed, an infantile—source of pleasure. Given that the real object of these discussions is poetry, the first necessity of the image is, essentially, that which gets ascribed to the *Aphrodite*: the dream, in other words, of direct bodily response. And so what was rhetorical in the case of *skiagraphia*, becomes narrative in the case of the *Cnidia*. If the world has never before seen an unclothed female goddess in marble, or at least never seen a figure with so complex a set of erotic solicitations, if the statue raises the question of desire in the presence of divinity and in the presence of art, then some imaginative and logocentric observers are going to be inspired, in the fashion of mythological etiologies, to tell backstories about that nakedness and that desire.

Stories are all very well; still, to the maker of words, or to the theorizer of words *in* words, language is troublingly abstract, mediated, nonsensuous, and anhedonic. The image—especially the crafted image as produced by an artist—offers the promise of functioning (I use Murray Krieger's invaluable term) as the natural sign, which is to say, a form of representation that delivers its signified in a manner that is universal and inevitable. Those who practice and theorize the visual arts are well aware that the picture is not much more of a natural sign than a piece of text is; but poets like to engage in the fantasy that there exists an artistic practice of some kind that

produces full-fledged signifieds. What more perfect instantiation of that idea than the production of an art object that passes the most fundamental test for the real presence of flesh and blood—that is, the capacity to inspire carnal desire? The image, one might say, is the eros of the word.

But *Aphrodite* in one way and Aristotle in another way (not to mention those bitter Tuscan vegetables) point to some complications in this set of formulas. For starters, words can never really become pictures, and pictures can never really become things. Once we place these truths before us, the story of the stain, along with those discursive materials erected around the *Aphrodite* concerning beauty, desire, nakedness, divinity, and art, no longer appears to be such a positive exemplum. After all, Murray Krieger's point about the "natural sign" is that it is an *illusion*, and we might say that no one suffers more under this misapprehension than those who love Praxiteles's statue in the wrong way. The lad who locks himself in the shrine experiences no complex or transformative mimesis in the presence of the aesthetic object; he is rather like those birds who fly down to peck at the grapes in Zeuxis's painting or (in a slightly more flattering story) like Cimabue, who attempted to swat the painted fly that his pupil Giotto added to one of the master's frescoes (Vasari, I.117). Only instead of pecking or swatting, he is staining.

From this set of limitations—in which, essentially, the word is trapped in a fetishistic relation to the picture—Aristotle rescues us. The snakes and corpses displace the operations of desire from the product to the process. They liberate the aesthetic experience from merely focusing on the direct replication of beauty, which is, after all, an extremely partial canon of possibilities in a world that contains tragedies and statues of old shepherds. They concentrate instead on an activity of recognition ("inference," "reasoning together") that

manages to hold both things and representations of things in a pleasure-inducing balance. Which, in the end, tends to reverse the picture-envy that swirls around the whole matter of word-and-image. This more complex set of aesthetic responses is, in fact, discursive: here, finally, is something words do *better* than pictures.

It is thus no coincidence that, whereas Socrates needed to understand mimesis as transparent (in common, *mutatis mutandis*, with the randy young man in the temple), Aristotle, whenever he adduces the parallel between the arts, focuses on the jaggedness of representation:

> Mimetic artists . . . can represent people better than our normal level, worse than it, or much the same. As too with painters: Polygnotus depicted superior people, Pauson inferior, and Dionysius those like ourselves. . . . This very distinction separates tragedy from comedy: the latter tends to represent people inferior, the former superior, to existing humans. . . . Since the poet, like a painter or any other image-maker, is a mimetic artist, he must represent, in any instance, one of three objects: the kind of things which were or are the case; the kind of things that people say and think; the kind of things that ought to be the case. (1448A, 1460B)

There are no simple mimetic ratios here: the heritage of all this material is a complex and reciprocal relation between recognition and desire—in a set of spaces formed by pictures but mediated by words.

Nor, reverting to Plato, is it a coincidence that the Socrates of the *Phaedrus*, speaking in a completely different context from that of the *Republic*, should once again summon up the analogical painter *in malo*:

You know, Phaedrus, that's the strange thing about writing, which makes it truly analogous to painting. The painter's products stand before us as though they were alive: but if you question them, they maintain a most majestic silence. It is the same with written words: they seem to talk to you as though they were intelligent, but if you ask them anything about what they say, from a desire to be instructed, they go on telling you just the same thing for ever. (275D)

What Socrates is promoting—and enacting—in this dialogue is a form of eroticized, or at least affective, communication that he calls "writing on the soul." In its own way, the argument is once again about Krieger's "illusion of the natural sign." The perfect way to deprivilege the conventionally written word is by appealing to the failure of visual representation to deliver reality, which is opposite to, and yet consistent with, all those exploitations of painting that seek to annex its promise of flesh-and-blood presence. Socrates wishes to install a different relation between recognition and desire.

However it is construed, that combination has been an underlying constant in much of the *ut pictura poesis* material that we have considered in these pages. In the ground zero passage from Horace's *Ars poetica*, the verbs are all about pleasure—*capiat, volet, placuit, placebit*—at the same time as the context is the judgment of the critic ("iudicis argutum quae non formidat acumen" [364; "because it's not afraid of the critic's sharp judgment"]). Elsewhere in the poem, he declares that "it is not enough for poems to be beautiful, they must be *dulchia*"—not just sweet, but affecting, emotional, productive of feeling. But the mechanisms of this feeling— "the human face laughs with the laughing and weeps with the weeping" (101–2)—enunciate a particularly complex relation

between pleasure and responsiveness, validating precisely that set of mirroring procedures about which Socrates was so anxious. The Zeuxis story takes us once again to recognition and desire. It is no coincidence that the subject of the statue is Helen, supreme exemplum of physical attractiveness; but the refashioning of the statue, which requires the composite translation out of real girls, complicates any simple erotic response: "He selected five, whose names many poets recorded because they were approved by the judgement of him who must have been the supreme judge of beauty" (2.1). And, as we have seen, the whole heritage of the anecdote tends precisely to worry the question of judgment in the face of beauty.

Finally, it hardly needs to be said that Ovid's *signum* and *imago* depend precisely on scenes in which beauty must not merely be experienced but also subjected to special forms of recognition. The tragic version is Narcissus, for whom consummation, even of the perverse kind that was practiced upon the *Cnidia*, is impossible; with or without the happy ending, the love of beauty must be channeled through a laborious process of recognition and self-recognition. The triumphant version is the closely related tale of Pygmalion, which can be read quite specifically as a rehabilitation of all the concupiscence and false consciousness implicit in the story of the stain on the marble. After all, Ovid has performed the great innovation of taking old legends about men in love with statues and turning the lover into the person who has actually sculpted the work. In that sense, far from committing a grotesque outrage upon her, he ultimately brings her to life with a combination of his artistic talent and his passion. His is not a recognition after the fact, like that of the helpless Narcissus, but a recognition that fulfills all the demands of transformative mimesis.

If Dante—as we saw in the previous chapter—became the medium whereby a whole vocabulary of the visual arts got do-

mesticated into literary theory and practice, we don't have to stray too far to discover the body of work that canonized pictoriality as the poetic topos par excellence of desire. Though it was canonical a century ago to dismiss Petrarch's interest in the visual arts as merely conventional and instrumentalizing, more recent work has reopened and complicated the question of this relation. We know that Petrarch produced drawings with his own hand, for instance in his manuscript of Pliny, which may suggest a set of associations between classical subjects and visual art, as does the very fact that he closely read and annotated the sections of the *Natural History* that treated the visual arts. We know that he owned paintings, notably a Giotto madonna, about which he writes in his will that its "beauty will not be understood by the ignorant, whereas the masters of the art are astonished by it" (Petrarch, ed. Mommsen, 79). That highly characteristic us-and-them gesture appears again when he is attempting to define the noblest form of *imitatio*, where he rejects the analogy to the relation between sitter and portrait—since in that case the closer the resemblance, the better—but embraces a more mediated, and also more mysterious, artistic comparison. The original and the imitation should resemble each other via "a certain shadow and something our painters call an 'air'" ("umbra quaedam et quem pictores nostri aerem vocant" [*Letters on Familiar Matters*, 23.19]). In other words, the riffraff who look ignorantly at pictures merely expect replication; whereas *we*—myself and *nostri pictores*—are in-the-know about a more complicated form of likeness, and we share a language for describing it, and a metaphorical language at that. All of these, admittedly fragmentary, references hint at a conception of current artistic practice (not unlike Dante's, but more positive) as a site for some sort of modernity with which he wished to associate himself.

As does the fact that he had commissioned a portrait of Laura from the other great painter of the age, who was more nearly his contemporary, Simone Martini. Or at least that in the two sonnets he composed on this subject—whose importance to the transmission of the word-and-image topos is the equal of Dante's *Purgatorio* cantos—he was developing a conceit to the effect that he had ordered, and was now contemplating, such a work. Whether this is a fact or simply another element in the fiction of Laura, we know that the poet and painter were together in Avignon for a considerable period of time. And there is the frontispiece that Simone executed for Petrarch's personal copy of Virgil (figure 3.9), which we do possess.

This extraordinarily beautiful miniature offers rich testimony concerning the place of the visual in relation to the textual. In a decidedly nonperspectival field, a figure with pen in hand and book in his lap reclines in what appears to be a laurel grove while gazing upward. Three other persons in contemporary costume are to be seen in the spaces around him, one tending animals, one pruning trees, and one holding a lance; a fourth individual pulls back a curtain as he points toward the reclining figure. We are, of course, looking at Virgil, who is positioned between heavenly inspiration and the matter of the book. The three figures on the circumference of the miniature make explicit reference to the *Aeneid*, the *Georgics*, and the *Eclogues*, in descending order of significance and of altitude within the image. The person who holds back the curtain with his left hand while—in what is arguably the most striking feature of the whole composition—he reaches across to the poet is Virgil's expositor, Servius, whose commentary was inseparably bound to the original text in this manuscript as in every medieval reader's experience of the ancient poet.

Within the frame, there appear two rhyming couplets, each held by a birdlike winged hand. The first one, "Ytala perclaros

3.9

Simone Martini, frontispiece for Petrarch's *Virgil* (1336). Biblioteca Ambrosiana, Milan. (Scala/Art Resource, NY.)

tellus alis alma poetas: / Sed tibi grecorum dedit hic attingere metas" (all citations from Brink; "Italy, kind country, you feed famous poets. But this one allowed you to attain the Grecian goals"), begins in a familiar vein, poised somewhere between historicism and eternalism, by implying an unbroken continuity between ancient poetic achievement and modern work undertaken on the same geographical ground. *But*—and that *sed* which opens the second line may be the most important word in the whole couplet—he leaves Italy behind in his search for yet grander frames of reference, all the more hypothetical, given the poet's self-publicized ignorance of Greek. No surprise that all of this implicates Petrarch himself, in the style of the autobiographical annotations in his *Natural History* manuscript at points where Pliny discusses habits of artists. In fact, the language involving Italy and Greece resembles the terms in which Petrarch arranges to have himself foretold by Ennius in book 9 of the *Africa*, and the very figure of the poet in the miniature has much in common with the language of that same passage.

The second epigram takes us further into the purposes of the entire project.

> Servius altiloqui retegens archana maronis
> ut pateant ducibus pastoribus atque colonis.

> Servius, recovering the enigmas of high-spoken Virgil, so that they are revealed to generals, shepherds, and farmers.

A kind of opposition between the two pairs of lines emerges here. The previous inscription was all about continuities: ancient and modern, Rome and Greece, Virgil and Petrarch. Now, however, it is revealed that there are fissures: Virgil's lofty discourse, it turns out, contains mysteries in need of elucidation. In a complicated hermeneutic conceit, Petrarch

takes the three canonical subjects of Virgil's own writing, which had helped construct hierarchical edifices concerning high, middle, and low style, and he transforms their respective representatives from the *matter* of poetry into the *audiences* of poetry. This is where Servius comes in and where the larger visual-verbal conception comes to light. In Simone's miniature, the soldier, the farmer, and the shepherd are not just plying their trades (indeed, each is looking *away* from the emblems of his occupation); rather, they are gazing at that central space where Servius's hyperextended hand leads them all to the site of the Master himself. What is happening in this collaboration is that discursive analysis and pictorial demonstration are being understood as in profound sympathy. *Ut pictura allegoria.*

That parallel readies us for the third epigram, which appears outside the frame of the image itself:

Mantua Virgilium qui talia carmine finxit,
Sena tulit Symonem digito talia pinxit.

Mantua bore Virgil, who fashioned such things in poetry;
Siena bore Simone, who painted such things with his own hand.

We are back in the realm of continuities: Mantua and Siena; Virgil and Simone; poetry and painting. But someone has dropped out of the mix. For all his centrality in the picture, Servius is not permitted to join this embrace across the ages. In effect, the compliment to Simone—and Petrarch loves to heap praises on his favorite artist—consists of the implicit assertion that his friend's modern art can stand not only beside, but even in place of, the efforts undertaken by the fourth-century grammarian. After all, soldiers, farmers, and shepherds, now construed as the addressees of Virgil's works, are

likely to be no more capable of comprehending poetic texts than Pope Gregory's illiterates, who required pictures in place of words. Simone can perform Servius's labor of transmission in a set of actions superintended by the (unnamed but ubiquitous) humanist, who, strictly speaking, doesn't need Servius *or* Simone for his own intimate relations with Virgil.

Clearly, then, Petrarch is capable of troping word-and-image at a richly theorized level in what we might think of as a generational advance on the *Purgatorio* cantos where the vocabulary of visual art was brought to bear on Dante's hermeneutic purposes. But where is Laura in all of this, and the element of desire? We do not have far to look. On the inside of the manuscript's front cover, Petrarch has written his famous piece of memorializing prose:

> Laura, so renowned for her own virtues and so much celebrated in my poetry, was first manifested to my eyes when I was a young man, in the church of Saint Clare in Avignon, at prime on 6 April 1327. In the same city, this world was deprived of her radiance at the same first hour, on 6 April 1348.... I am certain that her soul—as Seneca says of Scipio Africanus's—has returned to the heaven it came from. Writing this memorial of something painful, I feel a kind of bitter sweetness, particularly since my eye often falls on this place, causing me to reflect that this life holds no further pleasures for me, and warning me, by the constant sight of these words and from consciousness of the rapid passing of the years, that it is high time that I took flight from this Babylon of a world.

It goes without saying that this extraordinary piece of prose, by turns documentary and heart-wrenching, is in that quintessential Petrarchan mode of private-and-public utterance that raises fundamental questions about why, and for whom, any-

one sets down words on paper. Its presence in this spot, lucidly explained here for the benefit some difficult-to-hypothesize reader, reveals the connection in Petrarch's mind between Laura and the civilization of antiquity itself, as does the breath-taking *obiter dictum* equating his beloved's place in a Christian heaven to the afterlife of a great Roman general as celebrated in a Seneca letter, itself written in a proto-Petrarchan mode of site-specific introspection and nostalgia for simpler and happier olden days.

But it is the terms whereby the memoir of Laura belongs in a Virgil decorated by Simone Martini to which we must pay special attention. The message, to himself and posterity, is that every time he reads Virgil, he'll think of Laura; and he reads Virgil a lot. More to the point is the fact that this exercise of reading is itself characterized as ocular: "Hoc potissimum loco qui sepe sub oculis meis redit" ("my eye often falls on this place") and "crebra horum inspectione" ("by the constant sight of these words"), the result of which is "amara . . . dulcedine" ("a bitter sweetness"). Appearing on a page adjacent to the Simone miniature, this notation signals a kind of exercise whereby visual experience possesses not only an exceptional capacity in regard to memory and memorialization, but also an oxymoronic propensity for producing pleasure and grief simultaneously. That mix may be somewhat muted in the case of the Simone image—roughly, having to do with the gap between the seeming availability of a pictorial Virgil and the problematics of a not entirely recoverable text. But when the subject turns to the deceased Laura, the mutually contradictory and mutually reinforcing access of bitter and sweet moves front and center. Here and elsewhere, the picture is for Petrarch the very embodiment of his most characteristically paradoxical interior process: it stimulates desire, but cannot satisfy it—a circumstance that stimulates desire all over again.

The missing intersection of these two neighboring sheets in the Virgil manuscript, then, is the Simone Martini portrait of Laura, and if visual representation operates in a dialogic process between sweet and bitter, no surprise that the portrait becomes a point of contention in the *Secretum*. When Augustinus attacks Franciscus—"what could be more insane than this: Not content with the sight of her, this woman from whom all these miseries had come, you sought out another face, one made by the genius of a famous artist, so that, carrying it with you everywhere, you would always have cause for never-ending tears?" (3)—it is easy to forget that it is not *really* St. Augustine, but Petrarch, whose voice we are hearing. We are presented, therefore, not only with yet another compliment to Simone, but also with a fundamental piece of auto-analysis that goes one step further than the Laura memorial in the Virgil manuscript—revealing Petrarch's own awareness that he *wants* to suffer, indeed enjoys suffering, and that the picture is the perfect medium for this paradoxical (better: neurotic) mental habit.

Not that the picture is the only tool to stimulate these activities. Given that many of Augustinus's admonitions against loving Laura are themselves assertions of the poet's passionate desire for her ("With her coming, the sun rose; her departure brought the return of night. A change in her expression changed your soul. Depending on her least gesture, you are made happy or sad" [3]) and that they are indistinguishable from language in the *Rime* that makes no pretense of coming from St. Augustine, it is clear that the dialogue form itself is another of those push-me-pull-you modes of expression that purports to moderate desire while actually inflaming it. The parallel between these media is no accident, since for Petrarch the picture is itself the occasion par excellence for dialogue.

Which takes us, finally, to the two portrait sonnets. But by way of introduction to that work, let us gather a few strands from classical material we have considered in recent pages: Pygmalion, whose love summoned into amorous reality a work of art previously cold and emotionless; Socrates, who censures the work of portrait painters for producing simulacra that *seem* to have life and speech but never respond to the immediate stimulus of their interlocutors; and a further piece of the *Cnidia*'s textual traces, one of several similar epigrams in the *Greek Anthology* celebrating Praxiteles's work: "Paphean Cytherea came through the waves to Cnidos, wishing to see her own image, and having viewed it from all sides in its open shrine, she cried, 'Where did Praxiteles see me naked?'" (16.160). The visual art object, in short, functions at the nexus point of love, speech, and divine inspiration.

With that combination, we are ready for *Rime* 77 and 78:

Per mirar Policleto a prova fiso
con gli altri ch'ebber fama di quell'arte
mill'anni, non vedrian la minor parte
de la beltà che m'ave il cor conquiso.
Ma certo il mio Simon fu in paradiso
(onde questa gentil donna si parte),
ivi la vide, et la ritrasse in carte
per far fede qua giú del suo bel viso.
L'opra fu ben di quelle che nel cielo
si ponno imaginar, non qui tra noi,
ove le membra fanno a l'alma velo.
Cortesia fe'; né la potea far poi
che fu disceso a provar caldo et gielo,
et del mortal sentiron gli occhi suoi.

Even though Polyclitus should for a thousand years compete in looking with all the others who were famous in

that art, they would never see the smallest part of the
beauty that has conquered my heart.

But certainly my Simon was in Paradise, whence comes
this noble lady; there he saw her and portrayed her on
paper, to attest down here to her lovely face.

The work is one of those which can be imagined only in
Heaven, not here among us, where the body is a veil to
the soul;

it was a gracious act, nor could he have done it after he
came down to feel heat and cold and his eyes took on
mortality.

Quando giunse a Simon l'alto concetto
ch'a mio nome gli pose in man lo stile,
s'avesse dato a l'opera gentile
colla figura voce ed intellecto,
di sospir' molti mi sgombrava il petto,
che ciò ch'altri à piú caro, a me fan vile:
però che 'n vista ella si mostra humile
promettendomi pace ne l'aspetto.
Ma poi ch'i' vengo a ragionar co llei,
benignamente assai par che m'ascolte,
se risponder savesse a' detti miei.
Pigmalïon, quanto lodar ti dêi
de l'imagine tua, se mille volte
n'avesti quel ch'i' sol una vorrei.

When Simon received the high idea which, for my sake,
put his hand to his stylus, if he had given to his noble
work voice and intellect along with form,

he would have lightened my breast of many sighs that
make what others prize most vile to me. For in appear-
ance she seems humble, and her expression promises
peace.

Then, when I come to speak to her, she seems to listen
 most kindly: if she could only reply to my words.
Pygmalion, how glad you should be of your statue, since
 you received a thousand times what I yearn to have just
 once.

Perhaps the most significant thing for us about the two poems
is the opposition between them. *Rime* 77 views the portrait,
roughly, *sub specie aeternitatis*. The trope of the painted image
enables the poet to fantasize a perfection that preexists any-
thing he has himself created. It is rather like instances of classi-
cal ekphrasis that we considered in an earlier chapter, but here
this past existence is plotted both in the history of art and in
Christian eschatology, in each case with clear retrospection on
Dante, Beatrice, and the ekphrases of the *Purgatorio*. Polycli-
tus has a thousand-year history; Paradise has a longer history;
Simone has only a very recent history, seemingly. Each has la-
bored in its own respective way to produce that essence for
which the painting stands as a representation. And it is oppo-
sitional labor. It is perhaps no surprise that Petrarch's address
to this subject is via the nexus of comparison and competi-
tion. A poet who speaks of a painting is, inevitably, comparing
the two activities and, almost as inevitably, measuring their re-
spective strong points. Further, since the field of comparison
is likely to be mimesis, the topic will probably summon up the
competition between things and representations of things.

Polyclitus, the sonnet expresses definitively in the first qua-
train, couldn't possibly have made the appropriate portrait of
Laura because he would have needed to see her through the
poet's own loving eyes. Yet, as it turns out in the next stanza,
it isn't the poet's love that produced the portrait; it is rather
Simone's privilege (Christian? painterly? both?) in being ad-
mitted to heaven. Paradisaical or not, though, portrait-making

remains a material act ("ritrasse in carte") whose effectiveness operates by a notion of faith ("per far fede") that is simultaneously religious and mimetic. At the midpoint of the sonnet, then, we are allowed to envision a painting whose beauty represents the perfect delivery to earth of Laura's heavenly essence.

The fact that this is not at all the same thing as terrestrial mimesis—the terms, in other words, by which painted effigies are praised for being totally true-to-life—emerges in the sestet, where heaven and earth are disaggregated. Laura's portrait, as it turns out, is *not* the kind that we can *imaginar* (make images of; imagine) down here, where the *velo* (another term of art) of the body covers up the soul: Simone, in other words, has been able to paint not the body but the soul, which is quite the contrary of what poets might ascribe to the capacities of visual artists—for instance, Polyclitus, who possessed neither the entrance ticket to heaven nor the personal key to the poet's own desire. Yet that window has now shut. The painting was a medium of grace that cannot be repeated: its perfections are frozen now that Simone, and the rest of us, live in a world of mortality and change.

Fittingly, then, heaven completely drops out of the picture in *Rime* 78. The "alto concetto" is not localized, and the portrait emerges more or less as a contract between the poet's name and the painter's stylus. Nor is the speaker altogether satisfied with the deal. Whereas in *Rime* 77 picture embodied all the unmediated sublimity that mortal language could not contain, now the portrait is a mere visual effigy lacking both *voce* and *intelletto*—properties that belong to the writer but not the painter. The writer has his own limitations, though, because, rich in discursiveness though he may be, he cannot put words into Laura's mouth. He seems to fantasize fleetingly that the portrait would, if it were made articulate, respond positively to his desires (though lines 5–6 seem intention-

ally oblique in their meaning). In reality, though, her status as image radically limits her capacity to accede to his wishes. Merely pictorial assent is gravely insufficient: indeed, even the reading of it as assent can only be credited to the poet-viewer.

Which makes perfect sense because the scene that Petrarch creates here is an exquisite swerve on Ovid's Narcissus (partially via the *Roman de la Rose*), whose equally pictorial beloved can offer nothing but empty replication. The allusion digs the frustrated lover yet deeper into a hole, since it is not even as certain that his beloved is as responsive as was the object of Narcissus's desire; and the whole scene exposes the speaker as (in a word) narcissistic, helpless before an image whose only possible discourse consists of the vain imaginings imposed by the viewer himself. (Uncannily, since the *Phaedrus* was unknown to him, Petrarch has replicated Socrates's frustration before the inarticulate picture—though, to make matters even more complicated, Socrates is actually talking about *writing*.) In any event, Petrarch suppresses the embarrassing Narcissus in favor of the more self-congratulatory alternative, Pygmalion, whose self-created beloved—statue rather than painting but subject to much the same pictorial metaphorics—did eventually receive independent life. Even with this Ovidian bait-and-switch, however, the Simone portrait speaks far more convincingly to the emptiness of mere visual representation, as the poet begs for one chance in a thousand and ends up looking more like an idolater (or a fetishist) than a lover. Between Petrarch and the young man in the temple of Aphrodite there may be all too little distance.

If this is a perilous position for Petrarch, no one knew it better than he, given his extraordinary self-consciousness and given the media of dialogic self-interrogation that he regularly practiced. The lure of ekphrasis for a poet, as I have suggested a number of times in these pages, is the fantasy of a preexisting

object. But in this case that object—a portrait that is variously construed as heavenly vision and frigid simulacrum—renders the frustrated lover even more passive, less like Pygmalion and more like Narcissus. And the explicitly painterly gestures, credited to the speaker rather than to Simone Martini, that find their way into the *Rime*, such as "l'idolo mio scolpito in vivo lauro" (30; "my idol carved in living laurel") or "nel primo sasso / disegno co la mente il suo bel viso" (129; "in the first stone I see I portray her lovely face with my mind"), manage only to plunge him deeper into emptiness, given the insubstantiality of such hypothetical art objects. Petrarch does not seem to have been able to escape this vain pursuit via the Aristotelean snakes-and-corpses pathway: that will be left to Shakespeare, who, with the conceit of a "dark" Laura—ugly, sexy, quite the opposite of unavailable—reframes the whole Narcissus-Pygmalion dilemma by postulating a beloved who really *does* require the poet-lover in order to make her beautiful. By those economies, the poet is no longer a narcissist (at least if we omit the other object of desire in the Sonnets, the young man, in whose respect the poet abundantly takes up the self-love theme), and his praise for the lady is no longer a fetishistic act of gilding the lily. Or of staining the statue.

Shakespeare's (partial) escape serves to illustrate, *mutatis mutandis*, the double bind into which Petrarch has trapped himself and for which the conceit of the picture becomes the insistent embodiment. The portrait of Laura does not merely record her beauty, it stimulates the lover's desire while making satisfaction impossible; the voice of Augustinus, which Petrarch himself invented (as, indeed, he has perhaps invented the picture), attacks the self-enflaming, self-annihilating force of the portrait in language that, yet again, serves to intensify rather than tranquilize the sensations. Two other citations in the same mode will help reveal the larger ramifications of Laura and pictoriality.

The first is from the *De remediis utriusque fortunae* dialogue in which Ratio lectures Gaudium about the evils of taking pleasure in paintings. Gaudium scarcely opens his mouth except to utter a few forms of the verb *delectari*, while Ratio piles on precept after precept, instance after instance, against painting. No surprise that most of the material is taken from Pliny's *Natural History*, where it tends to appear in *praise* of painting.

Then Ratio, with truly Petrarchan self-awareness, curtails his tirade: "But I pass by these things, because, in a way, they are contrary to my intent to be brief and to my present purpose; they might, in fact, seem to contribute to the very illness I promised to cure, and to excuse the lunacy of connoisseurs by the sheer beauty of the artifacts described" (1.40). Painting, as imagined here, is never the work of Giotto or Simone Martini, consisting, in other words, of devotional images in Christian churches; it is always construed as classical. And the terms of its dangerous allure reveal the extent to which it is a synecdoche for all of ancient culture. Such an equivalence operates both as metaphor and metonym, with antiquity being imagined (the word itself gives everything away) as a form of picture viewed from an externalizing distance and also as a cultural unit that actually consists of pictures—indeed, that may be summoned up across that distance, to whatever extent possible, because of these remaining pictures.

If antiquity is a picture, it also turns out to be very much like a picture of Laura. As Ratio makes clear in the quotation above, the self-defeating mechanism is the same: the more you have, the more you want; the more you want, the more you lack; the more you lack, the less you have. And the hopeless alternatives for the "picture" are the same: vision inhabiting an unreachable paradise and frozen inarticulate beauty. All of this likeness operates, of course, because antiquity is itself the essential unresponsive *donna crudele* whose impossible attrac-

tions can be summed up in the notion of the image, toward which all the desperate efforts of the pursuer can be summed up in the notion of the word.

This set of equations can be observed with particular clarity in the *Triumph of Love*. It should be no surprise that Petrarch's *Trionfi* became a prime subject for early Renaissance classical image-making, since the entire conception of the work is of a distant civilization as framed pictorially. Whereas Dante in the *Commedia* travels through a sequence of dramatic scenes, the speaker in the *Trionfi* tends to be far more stationary and to have tableaux presented before him. The generative moment for the whole genre, just a few lines into the first section of the first triumph, makes this matter of visuality and pictoriality apparent:

> Vinto dal sonno, vidi una gran luce
> e dentro assai dolor con breve gioco.
> Vidi un victorïoso e sommo duce,
> pur com'un di color che 'n Campidoglio
> triumphal carro a gran gloria conduce.
> I', che gioir di tal vista non soglio
> per lo secol noioso in ch'i' mi trovo ... (1.11–17)

> Overcome by sleep, I saw a great light
> And within it much grief and brief joy.
> I saw a victorious and supreme leader
> Just like one of those who on the Capitoline
> Drive a triumphal chariot in great glory.
> I, who am not accustomed to enjoy such a sight
> In this dreary age in which I find myself ...

The first *vidi* in the poem is also the etiological moment for the whole genre, the moment when the ancient military triumph is explicitly harnessed to new purposes. This transfer is

explained via the very Petrarchan gesture of the poetic foot-
note, the revelation of his own source, which here turns on a
delicious ambiguity. Victorious leaders in ancient Rome did
drive triumphal chariots on the Capitoline, which Petrarch,
of course, could not have literally seen. But equally present
on the Capitoline were ancient reliefs that depicted such tri-
umphs; these *were* visible to Petrarch through normal sight.
In this double presence of the ancient past, and images of the
ancient past, we begin to see that the picture is for Petrarch
the mode in which he will render history.

But pictures on the Capitoline aren't the *only*, or even
the principal, impetus to these visions. Rather, what sets ev-
erything in motion is the tormenting experience of loving
Laura. What qualifies him as the privileged one-man audi-
ence for this vast pageant of (mostly classical) civilization—
comparable to the show that the (mostly Christian) universe
puts on for Dante—is his state of desire: this is what, in a quite
Althusserian sense, interpellates the speaker, summoning him
to account in the person of a guide whom he cannot name
(nor, in fact, can *we*, exactly), but who knows how to name
him. As the *Triumph of Love* reaches its concluding moments,
the vision of those who are enslaved by desire intensifies and
moves closer to home. From all the figures of classical history
and legend in the opening sections, we come at the beginning
of the last part to the poets who have been in love. Then it
is a short step to Petrarch's own direct autobiographical re-
flections, and finally to an unambiguous admission that he is
himself part of the shackled throng. But the relations between
history and personal history are complex:

> E 'ntanto, pur sognando libertate,
> l'alma, che 'l gran disio fea pronta e leve,
> consolai col veder le cose andate. (4.160–62)

And all the while, even as I was dreaming of liberty, I consoled my spirit, which my great desire had made sharp and lively, by looking at these things of the past.

It is a paradoxical dilemma that the poet is dramatizing. After all, the great desire that has put him in this prison is also the force that makes his soul receptive to beauty. And if he is attempting to comfort his spirit with gazing on things gone by, then the cure seems like more of the disease.

That gaze is soon framed in specifically painterly terms. The poet describes himself as one who is melted before the solar power of all these famous spirits,

> Quasi lunga pictura in tempo breve,
> che 'l pie' va inanzi, e l'occhio torna a dietro. (4.165–66)

Like seeing a long painting in a short time, when one's feet move forward but one's eye turns back.

3.10
Hypnerotomachia Poliphili (1499), sig. h8. (Princeton University Library.)

The entire experience becomes a picture, and the poet becomes the eroticized observer of his own canvas. As a result, far from achieving historical and artistic distance (which everyone from Petrarch onward has celebrated as the very definition of Renaissance), the poet loses himself in an amorous aesthetic fantasy of entering the picture and leaving history behind. While the poet's feet should be moving forward—in this instance, toward the later Triumphs, whose morality stands on a surer basis—his eye cannot help but succumb to the lure of the senses, the past, and his own acts of representation. Like one of those Renaissance painters who sneaks his own self-portrait into the corner of a crowd scene, Petrarch turns his own preceding poem into the object of desire that is looking out at us: after all, it is this split of his personality between foot and eye which definitively renders the speaker as part of the picture—that is, enslaved by love—rather than as

3.11
Hypnerotomachia Poliphili (1499), sig. q5. (Princeton University Library.)

its dispassionate framer. This particular worship of beauty—the erotic charge of the antique that leads a writer to make a picture and climb inside it, thereby stepping out of time—will become almost a signature in the establishment of Renaissance aesthetics.

For a salient sign of this process, we have only to look at a work that somehow manages at once to be almost freakishly eccentric and yet to embody many of the essential Renaissance preoccupations at a high degree of concentration. The *Hypnerotomachia Poliphili* recommends itself to us, most obviously, because it is the first great early modern publication in which text and image presented themselves as part of a grand and complex design (figures 3.10 and 3.11). We are not entirely

Sopra quahí que delle quale, di charactere Ionico. Romano. Hebræo. & Arabo, iudi el titulo che la Diua R.egina Eleuterilyda haueami prædicto & pronosticato, che io ritrouerei. La porta dextra haueu sculpta questa parola. THEODOXIA. Sopra della sinistra ǫsto dicto. COSMODOXIA. Et la tertia haueu notato cusi. EROTOTROPHOS.
Da poscia che nui quiui applicassimo imediate, le Damigelle comite incominciorono ad interpretare disertamente, & elucidare gli notandi tituli, Et pulsando alle resonante ualue dextere occluse, di metallo, di uerdaceo rubigine infecte, sencia dimorare furon aperte.

palmi ǫtro. Nelǫle in una facie, dal frōte dila fractura era iscripto, & similmēte oue era rupto p idicio di alcune litere pte fragmētate, & itegre, parte rimaste. Poscia nella subiecta corpulētia dalla circinante cinctura uerso el fondo, nellaquale erano appacte le anse, nel fronte dilla fractura era questa præstante scriptura.

Relicti questi rupti monumenti, ad una destructa tribuna deueni nellaquale alquanto fragmento di museaco si comprendeua. Oue picto mirai uno homo affligente una damicella. Et uno naufragio. Et uno adolescétulo sopra il suo dorso equitante una fanciulla, nataua ad uno littore deserto. Et parte uedeuasi di uno leone. Et quegli dui in una nauicula remiganti. Il sequente distructo. Et ancora questa parte era in molti lochi lacerata, Non ualeua intendere totalmente la historia. Ma nel pariete crustato marmoreo, era intersepta una tabula ænea, cum maiuscule græcæ. Tale epigramma inscripto haueu. Ilquale nel proprio Idiomate in tāta pietate me prouocaua legendo
si miserando caso, che di lachryme contenirme non potui, dānando la rea for
tuna. Ilquale sæpicule perle
gendo, quanto io ho
potuto cusi il se
ce latino.

certain who wrote the words, and we are much less certain who made the pictures. Indeed, we have no way of hypothesizing how this design came to be—whether, for instance, the images were an integral part of the (textual) author's conception of the work in the 1460s, given that it was not published until 1499. We do know that it was printed by Aldo Minutio (it was his first illustrated book, and he lost a lot of money on it), and we can certainly situate it in a world of Venetian and Paduan humanism, where visual and verbal material remains of antiquity were a fervent preoccupation.

For me, at least, it is almost impossible to think of the *Hypnerotomachia* without thinking of Mantegna. The range of his work, from the Vienna *St. Sebastian* (figure 3.12), with its little garden of broken antiquities and its Greek signature, to the Hampton Court *Triumphs of Julius Caesar* (figure 3.13), with their careful historicism and their gorgeously reimagined classical inscriptions, to the Louvre *Minerva Expelling the Vices* (figure 3.14), with its grotesqueries *all'antica* and its bizarre mix of exquisite lettering and nonsense alphabets, may be the best antidote to a scholarly sense that the *Hypnerotomachia* is too idiosyncratic to be adduced as a sign of its times. All these works, to be sure, demonstrate that, at least in one corner of Renaissance culture, words and pictures were seeking (and not yet finding) a canonical relationship in the representation of renewed antiquity. Indeed, on the pages of Colonna's romance, the two media reflect every possible connection and non-connection, from the most integrated and necessary sort of relation to irrelevance to mutual contradiction. Nor is this simply a matter of the book's composite design. The text itself, with its frequent invocation of the inexpressibility topos—you had to be there, you had to see it, words cannot describe . . . , all of this in the presence of images that offer partial, but only partial, material satisfaction—as well its constant recourse to

3.12

Andrea Mantegna,
St. Sebastian (1457).
Kunsthistorisches
Museum, Vienna.
(Erich Lessing/Art
Resource, NY.)

3.13

Andrea Mantegna,
*Triumphs of Julius
Caesar*, panel 4 (after
1486). Pinacoteca
Nazionale, Siena.
(Scala/Art
Resource, NY.)

3.14

Andrea Mantegna,
*Minerva Expelling
the Vices* (ca. 1502).
At right, detail of
image below.
Louvre, Paris.
(Erich Lessing/Art
Resource, NY.)

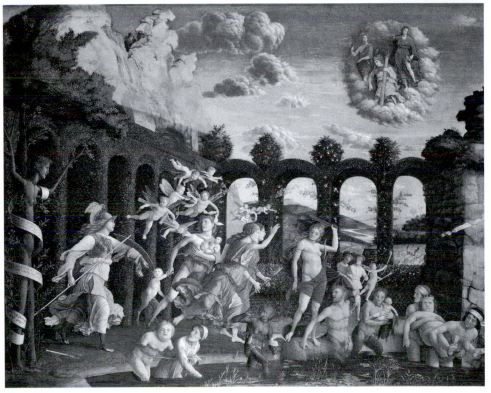

the idea of the hieroglyph, indissolubly bonds the dream of the antique with the dream of words that explain pictures and pictures that fulfill words.

But it's not the hybrid page-making of Colonna's book that principally recommends itself to us as the *ne plus ultra* exhibit of what Petrarch had initiated in the previous century. The *Hypnerotomachia Poliphili* is an erotic dream that is also an archaeological romance. The eponymous narrator experiences classic unrequited love for Polia, and in his tormented slumber he envisions union with her. Sexual union is indefinitely deferred even in sleep, though there are two or three occasions when the experience approaches what is all but explicitly a wet dream. The endless deferral consists almost entirely of his imaginative recreation in pictures and words of an antiquity that is subject at the same time to massive decay and fantastical modern reinvention.

So Poliphilo dreams of Polia but instead finds the ancient world. Or is it the other way around? The name Polia (and, after all, the hero is merely a subset of that name, being the *lover of Polia*) can signify many things—*literally*. But, principally among those things, it may signify hoary, white-headed antiquity. At the beginning of the romance, she is a painted image carved in his heart; at the end she is the solid column and pillar of his life (and he is, of course, the *colonna* of her life). Throughout the book, he experiences insatiable desires, but their object is not always clear. When we hear of his ravenous appetite and unspeakable desire, when he is "stupefied by an excess of pleasure," we may be surprised to learn (but only at first) that he is not talking about the woman but about a classical portico. The dynamic of this overwrought narrative interweaves the prospect of sexual satisfaction with ecstatic architectural ekphrasis. The works of the ancients are quintessentially ruined and fragmented (figures 3.15 and 3.16),

"destroyed," as the narrator says, "by insatiable and greedy time, by antiquity, by winds, rains, and burning sun." And it is precisely antiquity's ruin that makes it an erotic object—possessed of a hypothetical, though long-vanished, glory and simultaneously in need of a lover to fulfill its potential in both visual and verbal modes. Whether consummation is achieved any better in the antiquarian than in the erotic mode remains an open question.

And the same goes for the relation between the hero's quest and the operations of the book itself. So far as Poliphilo is concerned, at one of the numerous preconsummatory moments, Polia herself, in what is all but an explicit gesture of deferral, sends him off on an antiquarian expedition, urging him to "take his pleasure" with the ruined remains of a temple evidently de-

3.15

Hypnerotomachia Poliphili (1499), sig. a7. (Princeton University Library.)

voted to love. Quite right of her to do so: he reports that his "soul again felt the insatiable desire to . . . investigate fresh novelties" (262), a key notion, once again, in the way early modern writers conceived of the visual arts. The plan of distracting

Poliphilo works all too well: only after twenty pages of archaeology, antiquarianism, and art appreciation does it occur to him that something dreadful may have happened to his beloved, and even that comes into his mind only because he sees a crumbling image that reminds him of the Rape of Proserpina, whereupon his mind wanders to Aeneas's loss of his wife Creusa, at which point he finally recalls Polia. The *Hypnerotomachia*, in short, takes further steps in mapping the problematic Petrarchan—and Praxitelean—territory between sublimation and fetishism, demonstrating the extent to which the Renaissance culture of word and image, of antiquity and modernity, oscillates between the ennobling or etherealizing of desire and its perversion into the material, the inanimate, and the transitory.

What appears at a high level of concentration in the *Hypnerotomachia* is diffused throughout a Petrarch-influenced stand of early modern culture *passim*. The *ut pictura poesis* force of Renaissance humanism owes its energy to the fact that the classical heritage of picture and of text could not be disentangled. This is true in a material sense, with countless antiquarians searching for traces of the ancients that combined images and words. It is true in an iconographical sense, with whole industries of recuperation within which pictures and texts were being newly scrutinized for the mutual elucidation they could provide.

It is true in a methodological sense as well because, as regards words versus images, in the first place, the very conditions of survival or retrieval are different: the works of Zeuxis and Praxiteles are available only by conjecture, while reasonably authentic versions of Homer and Theocritus can fill any number of library shelves. But in the second place, this distinction also defines some of the essential features of the two media of expression, since the truth of the matter is that Praxiteles and Homer differ not so much for material reasons,

given that codices and books are actually more, not less, fragile than marble, but rather because we understand the notion of the ur-work differently as between statues and poems.

And, finally, the tangle of picture and text in humanism needs to be understood in a historiographical sense, given the fact that one of the most powerful and enduring claims about the early modern period goes back to the work of Erwin Panofsky and Fritz Saxl, who argued that the Renaissance came into being when the authentic images from antiquity were joined up with authentic texts from antiquity, whereas by contrast the medievals gave inauthentic captions to the authentic pictures they found and composed inauthentic illustrations for the authentic words they found.

The place of Petrarch in all of this is central, because he cared about—and theorized—both pictures and words and also because he scripted a lifelong romance, widely read and imitated, around episodes of discovering material remains that blurred the distinctions between book and picture. But more than these things he is central because he bestowed on this particular territory of European culture the model of desire and loss, and furthermore, as we have seen in these pages, because he turned that combination from a unidirectional transport into a perpetual motion machine.

The Theater *as a Visual Art*

Considering that this volume purports to illuminate the Renaissance, it seems to have spent quite a bit of time with predecessors. Plato and Ovid, Zeuxis and Praxiteles, Dante and Petrarch have occupied our attention, but only passing reference, or less, has been made to such matters as the ekphrastic traditions of High Renaissance Romance, the vast early modern library of picture books and emblem books, the careers of artist-poets like Michelangelo and Bronzino, and the traditions of visual iconography, along with their complex relations, as both source and destination, to verbal narrative. One reason for this emphasis is simply the body of my own previous work, where I have done what I feel I can do in the realm of these properly Renaissance subjects. A more substantial reason, perhaps, is the wish to be producing here something like a set of prolegomena, partly historical and partly methodological, to an understanding of the grand verbal/visual projects of the fifteenth and sixteenth centuries. But that preference for the wind-up over the pitch must itself be

interrogated—the more so since, as I reflect on it, it's a recurrent characteristic in my past work, where, for instance, Ovid threatens to steal the scene from the early modern representation of classical myth, or where rediscovered ancient sculpture almost entirely monopolizes a field where others might have allowed far broader occupancy by the great makers of Renaissance art who were inspired by it.

As it happens, this final chapter will only very partially redress this imbalance. But I take note of these chronological issues here by way of suggesting that if this habit of getting stuck among the precursors occasionally betrays (dare I admit it?) a deeper level of personal satisfaction with the ancients and the medievals as over against the early modern masterpieces that have so often been viewed as their triumphant pay-off, then there is one area where I am quite certain that the Renaissance was not merely reworking past practice, with whatever degree of originality, but was producing something quite new. As it happens, this realm of aesthetic accomplishment depends at least as strongly on earlier practices in the intersection of the verbal and the visual; but it ends up expressing itself in ways that are far more removed from its sources than is the case, say, with Vasari in relation to Pliny, or Michelangelo in relation to the *Torso Belvedere*, or sixteenth-century love lyric in relation to Petrarch. I am speaking, of course, of the theater and—let's be frank—of the *English* theater, and—let's be franker—of *Shakespeare*.

But, as always, let us step back a bit. In what ways—beyond the obvious—might theater be a visual art? Clearly, theaters are themselves pieces of architecture, which is a visual art; the stage is a space that is liable to be visually composed; and the whole experience of the drama—that is, all the relations among audience, building, and performance—are characterized by *seeing*. Whether these truths are anything but self-evident is another

matter. Perhaps the best way to begin fleshing out the subject is to consider just how the theater might *not* be a visual art. Looking at the matter from the beginnings of the Renaissance, the theater becomes one of those pieces of ancient civilization widely documented in surviving classical texts but currently more or less extinct and in need of revival. Like so many other cultural expressions, it exists as a set of old words that moderns give themselves the freedom to imagine, to image, and to realize in the flesh. But in the classical texts that give the Renaissance fullest license for envisioning places of public performance, the theater is far more an auditory than an ocular place. It is both surprising and chastening to scan Vitruvius's extensive account of Roman and Greek theaters, searching for any sense of the visual experience of a performance. There is some reference to the look of the building, and there are a couple of sentences about the famous περίακτοι, the rotating triangular set pieces that enabled scene changes. But the many pages devoted to the physical requirements of the theater are nearly all concerned with how well the audience *hears*. (Or else with how the audience gets in and out smoothly or with how healthy it is for them to be massed together.) In fact, the subject of the theater becomes for Vitruvius the springboard to a lengthy discussion of harmonics, acoustics, musical modes, overtones, and the way the human voice travels. And, skipping a millennium and a half, Alberti's *De re aedificatoria* will repeat precisely Vitruvius's emphases: health, traffic, and above all, sound.

I called this a chastening observation because nearly all the modern critical traditions of recounting the history of the theater take for granted the primacy of the eye. After all, the liveliest intellectual tradition in recent times concerning the place of Renaissance theater—I am speaking of the approaches made famous by Frances Yates—depends upon notions almost wholly visual; that is, the rendering of stage and

theater as a set of signifying geometric shapes and of differentiated places that the eye could use to structure discourse. As it turns out, the transit from ear to eye, from the work of Vitruvius to the work of Giulio Camillo, is conceptual as much as it is chronological. Humanist architectural theory in the Renaissance may preserve the notion of a primarily auditory theater, but humanists of a wider scope are too much in need of a medium that demonstrates, displays, or renders visible. Consider Juan Luis Vives in his *De causis corruptarum artium*:

> Poetry comes on to the stage, with the audience assembled to watch, and there, just as a painter offers a picture for the multitude to gaze upon, so the poet offers a certain image of life. As Plutarch has rightly said concerning these matters, a poem is a speaking picture and a picture is a silent poem; so the teacher of the audience is both painter and poet. But this art has been corrupted, having gone over from the just censure of shameful and criminal acts to the indulgence in depraved emotions. (6.98)

And Erasmus writes in a letter to an unknown recipient,

> The artful slave, the love-crazed youth, the suave and wanton harlot. . . . These characters are depicted for us in plays, just as in a painting, so that we may first see what is seemly or unseemly in human behaviour and then distribute affection or rebuke accordingly. (Letter 31)

Needless to say, neither Vives nor Erasmus has any connection to theatrical production—that may be the most important point of all—but both require a metaphor of visuality.

Why they require a metaphor of visuality will take us out of the realm of metaphor and into the real thing. The context for

both the above quotations is a discussion of Terence. Erasmus's letter, accompanying a Terence manuscript that he has copied out with his own hand, makes one of the classic humanist arguments concerning the worthiness of pagan literature in the face of objections that it is filled with sinful and corrupt sentiments: "I am convinced that the [comedies of Terence], read in the proper way, not only have no tendency to subvert men's morals but even afford great assistance in reforming them" (31). The "proper way" is to create a kind of Terence *moralisé*, not by allegorizing per se but by looking on the representation of immoralities as a way of exposing them to ridicule so that the audience will learn to behave otherwise. It is among the most familiar of claims about the effect of literature. What is worth remembering about it, though, is the extent to which it is based on the metaphor of visual display: "These characters are depicted for us in plays, *just as in a painting*, so that we may first see what is seemly or unseemly in human behaviour and then distribute affection or rebuke accordingly." The fact that Terence wrote for the theater gives humanists the chance to imagine the theater as a place where this form of moral exposure could be made literally pictorial.

As it happens, Terence's plays are also the site for a visual theater in an even more literal way. From the beginnings of their enormous postclassical popularity, the works of Terence are illustrated, often with displays of the characters as distinct, labeled, and organized types. Is Erasmus inspired to offer the analogy to painting because he has seen so many illustrations of Terence; or are there so many illustrations of Terence because the visual analogy is so central to the continuing authority of a text that displays and categorizes the varieties of secular human life? I don't know. But it is clear that through Terence's canonical status, the material visuality of the theater is indissolubly joined to its discursive operations as poetic text.

The fact that Terence's medium should be so susceptible to metaphor points to much broader ambiguities centering on the term *theater*. Despite Vitruvius's focus on the auditory, the word θέατρον itself derives from θεάομαι, "to behold"— rendering it, roughly, a place of seeing. Though most dictionaries, whether Greek, Latin, or English, take the primary meaning to be *space for dramatic performance* and the transferred or metaphorical meaning to be *place of visual display*, it is by no means clear from any of the history of its usages which of these meanings has priority. This uncertainty is particularly significant in uses of the term by medieval and Renaissance humanists. The countless volumes with titles like *Theatrum mundi* (Pierre Boiaistuau) or *Universae naturae theatrum* (Jean Bodin) or *Theatrum vitae humanae* (Theodor Zwinger) have nothing to do with the stage; they are all encyclopedias of one sort or another that use "theater" as a way of suggesting that the whole world is being arrayed for the visual delectation of a spectator. (Bodin is quite explicit on this point; his principal speaker is asked to "unfold the picture [*tabulam*] of the universe, just as in a theater, so that as if it were set before the eye for viewing, by distribution of everything the essence and faculty of each thing might be more clearly laid out" [10]). As an extreme case, Giulio Camillo seems to have imagined that the ancient theater was literally a kind of visual encyclopedia; and Pliny's account of the paintings on the walls of Pompey's theater gave some sort of vague sanction to such an idea.

The word becomes even more intriguingly indeterminate when the scene shifts to England. There, too, we find a cottage industry of encyclopedic theaters of the world, as for instance, Speed's *Theatre of the Empire of Great Britaine, Presenting an Exact Geography* or Jan van der Noot's *Theatre for Voluptuous Worldlings*, in which some of Spenser's works first saw print. Many early uses of the term have a primary meaning of visual

display, while others give evidence that the word was a slightly pretentious piece of classical borrowing that needed explication (and was not always explicated as a playhouse). It will also be remembered that for Elizabethans, at least, the word came to be indissolubly joined to public performance not by normal evolutionary usage so much as by an instance of commercial packaging, that is, when James Burbage in 1576 constructed a playhouse near Finsbury and called it "The Theatre." It seems to have been the first independent, purpose-built structure of its kind; its name had rhetorical force because it was not an ordinary word and because it was annexed from antiquity and from the prestigious world of grand folio volumes. The fact that the successor to "The Theatre" was called "The Globe" merely renders more explicit the promise to provide a living, visible, and universal encyclopedia, like Terence's *oeuvre* when construed by Erasmus or by Renaissance illustrators.

The theater, in other words, is a visual art not just because it happens inside architecture and not just because it can be pictorially composed but because its essential understanding of itself requires the analogy to painting. Of course, the premise of these pages is that *every* form of literary and linguistic operation—at least in the galaxy occupied by antiquity and the Renaissance—required the analogy to the visual arts. The defining formula that Vives cites—"Painting is mute poetry, poetry a speaking painting," along with its Horatian cousin *ut pictura poesis*—are only the most celebrated of the claims that rendered poetics dependent upon a theory of images. As I have suggested earlier, it is my belief that none of the foundational texts—not Plato's *Republic*, nor Aristotle's *Poetics*, certainly not Horace's *Ars poetica*—has ever been able to define or theorize poetry without making an analogy to painting and that this analogy is not simply a heuristic device but a fundamental and often occulted step in the theoretical process.

The argument that Socrates advances for the banishment of imitative poets from the Republic is based on an analogy to painters; and this originary fact has kept poetry entangled with painting and rendered it necessary for an analysis of both to be perpetually concerned with the metaphorical and tautological terms of the comparison.

What I did not emphasize earlier is that the theater—that is, the practice of spoken or staged poetic impersonation—was from the beginning an integral step in the making of these influential analogies. The mimesis that connects poets with painters in book 10 of the *Republic* is subjected to some elaborate definitions much earlier in the dialogue when Socrates engages in a lengthy set of interrogations designed to distinguish simple narrative poetry, as he describes it, from narrative-by-mimesis. The first category consists of what we would call third-person narration—indeed, Socrates provides a pretty appalling specimen by translating the opening of the *Iliad* into something like an impersonal plot summary. The narrative-by-mimesis, on the other hand, consists of verse that ceases to be in the poet's voice and pretends to be in the voice of the characters. "If the poet never concealed himself, his whole poetry and narrative would be free of imitation" (393D), says Socrates, thereby offering a significant clue to both the meaning and the moral value that he assigns to mimesis.

We must, of course, recall that the experience of the Homeric epics to a fifth-century Greek was that of an oral tradition, maintained by rhapsodes who were in both senses of the word interpreters—that is, performers and commentators. Thus the voice of Chryses, with which the *Iliad* begins, would not be a piece of typography inside quotation marks but a performed impersonation. It follows that the kind of poetry we call dramatic or theatrical would be less distinct from epic or narrative than it appears to us. And, in fact, the imperson-

ator becomes as crucial (and as logically problematic) as the painter in defining and judging poetry as an attempt to make real that which is not real. If the painting of the chair is one rhetorically problematic equivalent to the way in which poetry imitates reality, then the performer who speaks as though he were Chryses or Agamemnon is another. Yet an equation that reads "actor is to character as poet is to reality" is no more reliable than the one that connects the painting of the chair to the making of the *Iliad*.

Aristotle, even though he draws elaborate distinctions between epic and tragedy, takes over, at least implicitly, the equation between the actor and the poet, in effect subsuming enactment into imitation. When he declares that "the poet should . . . put things before his eyes, as he then sees events most vividly, as if he were actually present" and goes on to say that "the people who actually feel passion are the most convincing," he is working off of an implicit theatrical metaphor. "The person who most realistically expresses distress is the person in distress," he says, responding to the anxious Plato, who specifically does not wish to see the actorly (or painterly) imitation of distress at all (1455A). (No coincidence that in the next sentence Aristotle attacks the Socratic equation between the poet and the madman.)

But it is the heritage of these remarks in Horace's *Ars poetica* and beyond that most particularly fixes the triune relations of poet, painter, and actor:

> It is not enough for poetry to be beautiful; it must also be pleasing and lead the hearer's mind wherever it will. The human face smiles in sympathy with smilers and comes to the help of those that weep. If you want me to cry, mourn first yourself; *then* your misfortunes will hurt me. . . . If your words are given you ineptly, I shall

> fall asleep or laugh. Sad words suit a mournful counte-
> nance, threatening words an angry one; sportive words
> are for the playful, serious for the grave. (99–107)

Horace is confusing roles here almost to the point of in-
comprehensibility. He is ostensibly speaking about the po-
et's choice of words. But what is this poet's countenance to
which his poem must be suitable? And is the poet furnishing
words to a face or a face to words? It makes sense when we
understand that Horace is addressing the poet-as-actor. The
poet-as-poet, on the other hand, has no visible countenance,
so the relation of role to actor—one might say a Stanislavkian
relation, in which the two are closely enfolded together—
becomes a way of figuring the much less easily described rela-
tion between the poem and the poet. Or, one could say that
the relations between poet and reality and between audience
and poem—both difficult to describe—are being defined in
parallel, all by the rhetorical intervention of the actor.

I belabor the implications of these Horatian lines because
they will take on the status of dogma in Renaissance writing
about the visual arts. Their attraction doubtless lies to begin
with in their reference to facial expression, so that they seem
to be offering practical advice to painters. Alberti in *De pic-
tura* will canonize this reading:

> A "historia" will move spectators when the men painted
> in the picture outwardly demonstrate their own feel-
> ings as clearly as possible. Nature provides . . . that we
> mourn with the mourners, laugh with those who laugh,
> and grieve with the grief-stricken. Yet these feelings are
> known from movements of the body. (¶41)

Painting becomes—more logically, in a sense, than poetry
ever was—the mirror that produces (or is produced by) recip-

rocal reflections between reality and spectator. By the other end of the Renaissance, in the work of Lomazzo, these lines turn into what Rensselaer Lee calls "a *reductio ad absurdum* . . . of the modern theory of empathy" (218). Leonardo's *Treatise on Painting* has spectators not only smile with the smiling but also experience desire with the desirable, eat with those who are eating, and—this is my favorite—sleep with those who are sleeping. (Leonardo has already discussed how portraits of people yawning make the spectators want to go to bed [22].) Yet in all of this we must not forget that the generative phrase is still Aristotle's requirement that the poet "should . . . put things before his eyes . . . , as if he were actually present": that is where this territory of the visual and the theatrical will become so semantically crowded.

Now, this matter of presence and of things put before the eyes points to a very considerable body of ancient discourse that takes us into yet another realm where the verbal and the visual are entangled. It is difficult to tell exactly how early the term ἐνάργεια became current, but it is clear that throughout later antiquity the criterion of vividness was being enshrined as the supreme goal of successful linguistic composition, for instance, in a frequently cited passage where Dionysius of Halicarnassus is discussing excellences in speech-making. *Enargeia*, he says, "consists in a certain power [Lysias] has of conveying the things he is describing to the senses of his audience, and it arises out of his grasp of circumstantial detail" (7). Up to that point, it seems like a quite general term of praise—close description of some nonspecific kind stimulates the five senses of the reader/listener—but as the passage continues, and as dozens of other late antique citations of the term indicate, this ultimate canon of verbal success is all about eyesight. Lysias, Dionysius tells us, makes each listener "feel that he can see the actions which are being described going on

and that he is meeting face-to-face the characters in the orator's story." In only slightly varying formulations, the notion of words putting things *ante oculos* or *pro ommaton* appears in the *Ad Herennium* and in the work of Cicero, Quintilian, and Longinus, among others.

Yet the very ubiquity, not to say banality, of this metaphor demands that we examine more closely the manner in which it flourished. Like many other such intermedial formulations, it lends itself to being understood as a sort of simplistic equation, but a more careful reading exposes shadings of difference and instability. For one thing, there is a telltale caution expressed in many of these passages: "*paene* ante oculos" (Cicero, *De partitione oratoriae* 6.20; my emphasis) and "ante oculos esse videatur" (*Ad Herennium* 4.34.45). (After all, the very term for "seeming" in Latin is based on *seeing*.) More significantly, when these same commentators investigate the process by which language may attain this form of ocular reality—and they frequently *do* interrogate their own metaphor—they tend to invoke terms like φαντασίας or *visiones* (e.g., Quintilian, 6.2). In other words, the system through which words become visible depends on the postulate of a rather special, and not quite literal, form of visibility, one that might be encompassed in the (equally pictorial) term *imagination*, with all its labile—and, as Quintilian makes quite explicit, dangerous—mix of the real and the fictitious.

But there is another element in the antique life of *enargeia* that will bring us slightly nearer to theater. Just as important as the shadings of meaning that the term may have enclosed within itself is the range of its currency. Modern scholarship has demonstrated how this linguistic criterion of excellence traveled in some quite extraordinary ways between oratory and poetry, discourses that often kept quite suspiciously to themselves. To praise Lysias, Dionysius cites Homer; to cele-

brate the qualities of perfect speech-making, Quintilian cites Virgil. Longinus, looking back on this lengthy conversation, indeed feels the necessity to distinguish the two strands of vivid description: *enargeia*, he says, belongs to the orators, whereas the poets wish to produce *ekplexis*, or astonishment.

What is at stake in either the making or the blurring of distinctions here is the question of truth. Much depends on whether this bottle of verisimilitude is half full or half empty. The visibility test for language, which, as we have seen, comes with built-in reservations as regards the literal veracity of the verbal act, is well suited to an activity like poetry, where imaginative invention is expected, and even to an activity like speech-making, where truth may be allowed to take a backseat to persuasiveness. But that leaves the third discourse—historiography—where *enargeia* is also construed as supremely praiseworthy; and here the criterion of authenticity is not so readily deconstructed, since a claim for the absolute delivery of the past on the pages of a history book is more or less de rigueur. The consequence of this problematic is that history-writing in effect turns into performance.

The *enargeia* of Thucydides, Plutarch declares, results from "his desire to make the reader a spectator, as it were, and to produce vividly in the minds of those who peruse his narrative the emotions of amazement and consternation which were experienced by those who beheld them" ("On the Fame of the Athenians," 347a). No surprise that this appears in the same passage where Plutarch invokes Simonides on the mute poem and the speaking picture. And these articles of praise go beyond those bland equations to help ground a whole discipline of history-writing that is based on spectatorship. As Andrew Walker has shown in a quite brilliant article, historians like Polybius and Dionysius of Halicarnassus, writing in the tradition of Thucydides, quite self-consciously construe their

project as one in which the visual test of truth soon becomes a theatrical test of truth, in the sense that the grand events of the past—typically, speeches and battles—seem to be enfolding as if on a stage with (as Plutarch says) readers becoming viewers. Indeed, as Walker demonstrates, the metaphor of the theatrical spectator becomes not only a description of the reader's relation to the events being chronicled but also a fundamental dynamic inside the historical narrative itself, with many instances of the *mise-en-abîme*, where past episodes of events and spectators are recounted so as to figure the way in which the history readers themselves are supposed to relate to the text. In effect, the historical past, via the visual implications of *enargeia*, becomes a piece of living theater.

Now, this transit of poetry, oratory, historiography, and theater should remind us that the independence and interdependence of discourses like these, along with the debates accompanying them, are not merely theoretical but also institutional. Poetry and painting (to return to the principal coordinates in these pages) have one kind of historical sibling rivalry, with the painter's privilege of immediacy and the poet's privilege of greater cultural prestige often going head-to-head. But the theater is perhaps in an even more salient way an institution in need of a history, a theory, and a social space. Its rhetorical entanglement with poetry and visuality conditions its way of playing this game. What renders the theater special among these debates is the ever-present possibility that it will make poetics literally visible, that it will take the *ut* out of "ut pictura poesis," that it will realize the promises implicit in all those definitions of poetry that want to give it presence and materiality. So, to return to the example of Terence, there is no coincidence in the fact that his oeuvre is understood as a conceptual painting *and* that his stage practice is the subject of constant visual illustration. This is the

realization of what Vives means by "venit in scenam poesis": poetry comes on stage.

If there is one place where all the theoretical problematics of analogy, comparison, and contrast hit the fan in actual practice, that is early modern England. A combination of factors brings these elements into tension: the (relative) absence of a high-prestige culture of real paintings and sculptures; a fashion during the later Elizabethan period for extravagantly visual and ekphrastic poetry; the great flowering of the public theater, perhaps even as a kind of substitute for all those missing frescoes and marbles; and, concomitant with that flowering, a virulent anti-theatricalism. I have my own notions of the economy among these forces. I have argued elsewhere that the absence of a material art culture produces a desire that is directed variously toward poetic ekphrasis and theatrical realization; at the same time religious iconoclasm will attack, or at least be very anxious about, the representational, idolatrous, or hedonistic qualities of any of these forms of production. However these forces work upon each other, they all come together in the most significant piece of writing on poetics from this time and place, Sir Philip Sidney's *An Apology for Poetry*.

Sidney is, to begin with, a very direct inheritor of all those traditions that make poetics a dependency of imagistics. As he famously defines it, "Poesy therefore is an art of imitation: for so Aristotle termeth it in the word *mimesis*, that is to say, a representing, counterfeiting, or figuring forth—to speak metaphorically, a speaking picture" (18). It is one of the most celebrated of all definitions of poetry, and, like so many other such definitions, it arrives at saliency by drawing an analogy to the visual. And that connection becomes even stronger when Sidney goes on to characterize the poet as growing "in effect another nature, in making things either better than nature bringeth forth, or quite anew, forms such as never were in

nature." This is quite precisely the Horatian strand of poetic and painterly freedom that had become the stock in trade in treatises about the painter.

But in an equally significant strand of his argument, Sidney offers an extremely disparaging account of contemporary theater. In effect, he must disentangle *enargeia* poetics from theatrical realization. Sidney wants his poetry to speak pictures, but he does not want the pictures to be real. A picture that really talks is for him something of a freak show: "What child is there that, coming to a play, and seeing Thebes written in great letters upon an old door, doth believe that it is Thebes?" (57). Later, he will offer his notorious denunciation of the contemporary stage plays, "where you shall have Asia of the one side [of the stage], and Afric of the other, and so many other under-kingdoms, that the player, when he cometh in, must ever begin with telling where he is, or else the tale will not be conceived" (75). The problem for Sidney is that the theater is truly and literally a speaking picture. This is why he construes it as a series of clumsy interactions between what gets produced in words—"Thebes" written on the door or the actors explaining where they are—and what is visible to the eye and the imagination. The doctrine of poetry as the speaking picture turns out to depend on the imaginary (in all senses of the word) qualities of the picture and on the "speech" being internal and private. For Sidney, the theater suffers both from a literalization of his metaphor and from a social debasement of the mimetic function: when stage plays are shown to the masses, the literary act of imaging is at once made physically manifest and taken out of the hands—or minds, or eyes—of the privileged individual imaginer.

Sidney's very impetus to write the *Apology*, it should be remembered, was Stephen Gosson's *School of Abuse*, which launched a broadside Puritan attack on both poetry and the-

ater. It is not surprising that as a result Sidney should compose a treatise that navigates very carefully in the choppy waters where all the aesthetic media are struggling among themselves and with the figures in temporal and spiritual power. Nevertheless, Sidney's strictures will not prevent a vigorous entry by the theater into the arena where image and word combat and/ or complement each other, where poetic utopia and generic monstrosity both manage to sell tickets. The stage will be the real place where the rhetoric of mute poetry and speaking pictures as well as the institutional warfare is enacted. If for Sidney the theater was an all *too* literal realization of the speaking picture, I would argue that the dramatists, and especially Shakespeare, are quite aware of trying to turn this judgment around and use it for their advantage.

I am going to offer three glimpses at this process whereby the Elizabethan theater plays the role of a humanist treatise explaining, historicizing, and promoting itself. Since we already have *poetry* and *painting*, let us designate these categories as *perspective*, *performance*, and *paragone*.

Perhaps the most powerful bond of all that joins Renaissance theater to the visual arts is contained in the term *perspective*. I suggested earlier that one reason why the painter became essential in poetics was to objectify the problematic of point of view: the physical space of beholding a picture became a way to discuss the glories and anxieties attendant upon the realization that every artistic object becomes at least in part the property of those who experience it. For the Renaissance, perspective is the discipline that arises around this issue. And the theater will become the epicenter of the Renaissance obsession with perspective. One can hardly look at the great picture-frame stages of the later sixteenth century in Italy (figure 4.1) or, alternatively, at the operations of the royal masque in England (figure 4.2) without being aware that the

143

playhouse is physically and conceptually structured on post-Albertian lines. Nor is this perspectivism limited to lavish indoor proscenium theaters. Representations of the London public stage (figure 4.3) often include floor lines leading to a vanishing point; in fact, this device becomes a semiotic for theater when actual historical personages are depicted. We know that we are looking not at the real Moll Frith (figure 4.4) but rather a theatrical one because she has lines under her; and the same holds true for Queen Elizabeth (figure 4.5).

4.1

Andrea Palladio,
Teatro Olimpico
(1585). Vicenza.
(Erich Lessing/Art
Resource, NY.)

In effect, the Renaissance theater has become a sort of realization of the perspective box. The Albertian geometry was a way to translate three dimensions into two, thus mapping the relativity of perception; the theater, for its part, is a retranslation of two dimensions into three. But these three dimensions, having undergone double metamorphosis, are hardly identical to the "real world" three dimensions at the beginning of the process, any more than *enargeia* was the same thing as literal seeing. For one thing, you can call your theater the Globe, but it will always be much shallower than the universe. For another, the three dimensions of the stage will remain marked by the artificialities and relativities that produced them perspectively. So stage space will always have the qualities of a picture

4.2

John Webb, drawing after Inigo Jones, *Scene from a Masque* (early seventeenth century). (Provost and Fellows of Worcester College, Oxford.)

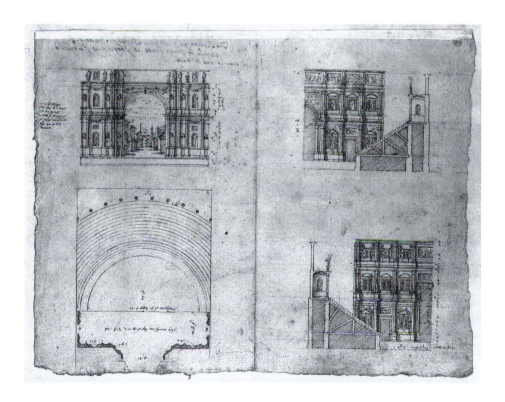

that has come to life, at least as much as it has the qualities of a reality that happens to have been framed.

What renders this a distinction worth making is the part about Renaissance linear perspective that usually gets forgotten. Alberti's is a discourse of geometry only up to a point (so to speak); what he is really concerned to promote is a discourse of *narrative*. "The great work of the painter," he says, "is the 'historia'; parts of the 'historia' are the bodies, part of the body is the member, and part of the member is a surface" (*On Painting*, ¶33). In other words, the whole geometric account of concretizing that surface perspectively is the first step toward structuring a reality in which groups of human bodies are arrayed so as

to tell a story. A successful composition (and that word itself embraces the whole process) includes novelty, variety, decorum, range of affect, and a recognition of the spectator's need to read and interpret the story. The technical operations of perspective underlie the composition because the entire system—and not just the visual perception—is built on the problematics of the space between picture and spectator. Alberti himself uses the analogy between his painting and the theater: "I do not like a picture to be virtually empty, but I do not approve of an abundance that lacks dignity. In a 'historia' I strongly approve of the practice I see observed by the tragic and comic poets, of telling their story with as few characters as possible" (¶40).

4.3
Title page,
Nobody and Somebody
(1606). (Beinecke
Rare Book and
Manuscript Library,
Yale University.)

4.4
Title page,
The Roaring Girl
(1611). (Princeton
University Library.)

4.5
Title page,
If You Know Not Me
(1633). (Princeton
University Library.)

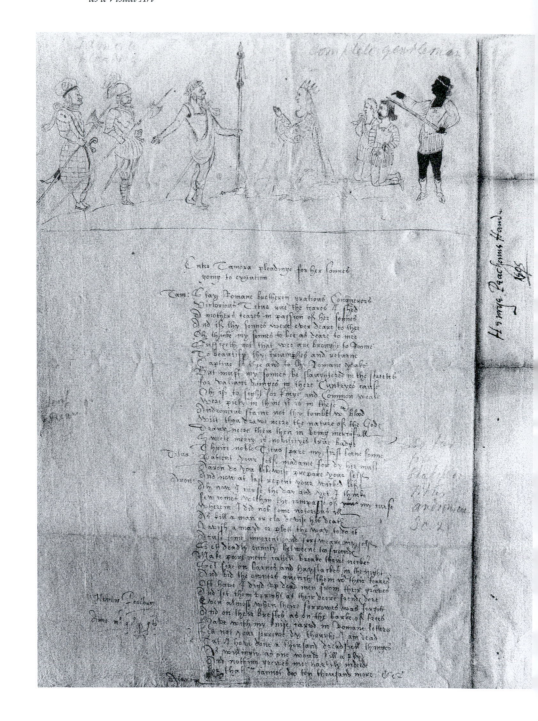

As a sign that Alberti's analogical theatricality could be quite real, and as a way of bringing all this back to Shakespeare, let us consider a fascinating and mysterious manuscript page (figure 4.6), which consists of some text from *Titus Andronicus* and perhaps the most complete version of a real stage picture that we possess from the Elizabethan public theater. The image seems to have been drawn by Henry Peacham, probably in 1595, that is, shortly after the publication of the play. We cannot determine whether the picture was drawn to illustrate the text, whether the text was found to caption the picture, or what relation either has to publication or staging of the play. In fact, it is a composite: the figures, who clearly include Titus, Aaron, Tamora, and (perhaps) her two sons, correspond to no moment in the play; and the words below are a similar mélange, including bits from act 1 and act 5. Though it is no masterpiece, the image records a living Albertian *historia*, with its focus on the center point, its way of creating narrative by a composition of bodies, and even its use of the pointer figure—significantly, the black man—as Alberti says, to "tell the spectators what is going on, either beckoning them with his hand to look, or with ferocious expression and forbidding glance challenging them not to come near" (¶42).

Misremembered textuality emerges as Renaissance narrative art theatricalized. Of course, perspective is not merely a visual effect; it is also an important word in the vocabulary of seeing. It is almost too postmodern to be true that in Elizabethan usage the term refers not only to the Albertian science of representing visual perception but also to the special kind of picture—famously, Holbein's *Ambassadors* (figure 4.7), for instance—that radically distorts perception except when viewed from a very oblique angle. For Shakespeare, the perspective glass almost literally deconstructs vision. In *Richard II* the bereft queen is told that

4.6

Henry Peacham, drawing after *Titus Andronicus* (1595). (Art Archive at Art Resource, NY.)

4.7

Hans Holbein
the Younger,
The Ambassadors
(1533). National
Gallery, London.
(National Gallery,
London/Art
Resource, NY.)

sorrow's eye, glazèd with blinding tears,
Divides one thing entire to many objects—
Like perspectives which, rightly gazed upon,
Show nothing but confusion; eyed awry,
Distinguish form. (2.2.16–20)

And in Sonnet 24 the conceit of the lover stamping the be-
loved's image on his heart is likewise submitted to pictorial
dissolution:

Mine eye hath played the painter, and hath steeled
Thy beauty's form in table of my heart;
My body is the frame wherein 'tis held,
And perspective it is best painter's art. (1–4)

Both passages are characterized by exceptional linguistic ambiguity, as though to mirror the problematics of perception. What remains true in both cases—and I would say true of the Albertian topos and of its realization in the theater—is that perspective is simultaneously a distortion and a clarification. It becomes that aspect of theater or painting which focuses on the space of beholding and identifies the artistic product as a representation.

If *perspective* is a visual arts term transferred to theater, then *performance* would seem, from modern usage at least, a theater term plain and simple. A census, both of Shakespeare and of usages contemporary to him, proves otherwise, however. *Perform*, or *performance* are almost never used during this period in the absolute sense—that is, without a specific object—as referring to theatrical staging. Generally it is not plays but services, wills, offices, bidding, and the like that are performed. On the other hand, we have the following somewhat surprising instances, one very well known, the other less so. First, from the denouement of *The Winter's Tale*:

> The Princess, hearing of her mother's statue, which is in the keeping of Paulina, a piece many years in doing, and now newly performed by that rare Italian master, Giulio Romano, who, had he himself eternity and could put breath into his work, would beguile nature of her custom, so perfectly he is her ape. (5.2.85–90)

And, from *Timon of Athens*, a dialogue between the poet and painter, who are plotting to get back in Timon's good graces now that he appears to be rich again. The poet speaks only in vague terms about offering something for Timon's patronage, but the painter offers up a whole theory about artistic promises and their fulfillment:

Promising is the very air o' th' time; it opens the eyes of
expectation. Performance is ever the duller for his act,
and but in the plainer and simpler kind of people the
deed of saying [i.e., the accomplishing of what is ver-
bally promised] is quite out of use. To promise is most
courtly and fashionable. Performance is a kind of will
or testament, which argues a great sickness in his judge-
ment that makes it. (5.1.23–28)

Both these passages associate *performance* with pictorial
work specifically, while allowing for its appropriateness to
the verbal arts.

But I am not for the moment so much concerned with the
switch-hitting aspect of the word—though it is significant that
Shakespeare so directly exploits it—as with the continuities of
its meaning. Divorced of any particular direct object, *perform*
means to carry through to completion. If this account seems
to be thrusting the word under an overly high-powered micro-
scope, it is no more than what is done by a particularly em-
inent Shakespearean linguist/semanticist/deconstructionist,
Hamlet's Gravedigger, whose argument about Ophelia's sui-
cide hinges on the assertion that "an act hath three branches:
it is to act, to do, and to perform" (5.1.11–12). I will not unpack
the ways in which this is both sense and nonsense, both a com-
ment upon and a parody of Hamlet's problem throughout the
play, except to say that it is a pastiche of some quite specific
legal language concerning the suicide of Sir James Hales,
which took place in the 1550s; in that case, the three parts of
the act were defined as Imagination, Resolution, and Perfec-
tion. When *performance* becomes a term for artistic produc-
tion, it refers to the finished work as the carrying out of some
preexisting intention—in simple terms, the staging of a script
or the completion of a commission.

Hermione's statue is the perfecting of her life and the earlier part of the play. The case of *Timon* is more complex. The painter, like everyone else in the play, unproductive and thoroughly corrupted by sycophancy, declares that promising counts for everything while performance is dull, unfashionable, and essentially a last will and testament on an intention that proves to be dying if it is carried out. Through this perverse reading, Shakespeare attacks a whole set of Renaissance traditions associated with the visual arts: first of all, the practice of patronage, which depends on promising and performing, and second the idea of the *Idea*—that notion, so nicely characterized in Panofsky's book of the same name, that the true greatness of a work of art consists in the inspiration that lies behind it. Shakespeare's theatrical art—and I find the implicit competition as present here as it will be in the case of Hermione's statue—neither depends on corrupting relations to patrons nor is it characterized by the elevated Platonic discourse of the *idea*. The practice and the ideology of the visual arts become a means of defining and celebrating the theater.

With that, we arrive at the last term. *Paragone*, which refers at once to the comparison and the competition between different arts, is not a Shakespearean term at all, though the recurrent reference to Zeuxis's modular painting of Helen (discussed in chapter 2), applied alike to Miranda, Imogen, and Hermione, suggests his interest in the creation of a *paragon*. At all events, the *paragone* is born in disputes within the visual arts and soon extends beyond them. We could call it the Church Militant of *ut pictura poesis*, the place where the theorizing of the arts and the institutional struggles among them coincide. (We need only recollect the arguments in Sidney's *Apology* about poetry versus history and philosophy to be aware that the *paragone* was alive and well among Elizabethans.)

The *paragone* is a medium of theory because, as I suggested earlier, the arts are able to define themselves largely by reference to each other and generally in terms of their means of representation. Mimesis is by its very nature a discourse of competition—or, at the very least, of comparison. I take as the Shakespearean icon of this proposition the moment in Gertrude's chamber when Hamlet seizes the two cameo portraits of his father and uncle—that, as it happens, was a visual art that *did* flourish among the Elizabethans—and submits them to a pitiless comparison. The agonistic relations that mimesis establishes between representation and thing represented generate in turn the theoretical contrasts—or contests—among different media of representation. Shakespeare makes of the theater an arena in which the relative powers of language and visuality are being perpetually tested for their ability to make the imaginary real. In this particular metadrama, the plot is always the same: poetry makes its claim, visuality makes *its* claim, theatricality trumps them both by embracing them, by turning the lyric voice into conversation and translating the frozen artistic image into motion. Hermione-as-statue—to return to the often analyzed final scene of *The Winter's Tale*—is first introduced in absentia via a long verbal description; then she is seen as a work of visual art, mute and stationary; finally, she moves and speaks.

In short, the Shakespearean theater is perpetually containing and staging an inscribed picture, creating it in language and in the flesh, then triumphing over it. In these terms the Shakespearean theater is a continuous ekphrasis, exploding the terms that he established during Lucrece's episode of art appreciation. Given that they do not possess the possibility of realizing a Troy painting on stage, the plays must constantly create verbal fictions about visual experiences that the audience is not really having. That is, of course, the substance of all

those exhortations in the choruses of *Henry V*, which essentially attempt to talk the audience into an experience of imagination (in all senses of the word) transcending picture and word. But this is so universal a procedure in the drama that it hardly counts as referring to the visual arts. I want to close with some episodes that are more narrowly speaking ekphrastic, where there is a crafted visual object that Shakespeare's words create and then outdo by the surrounding theatricality.

The first is Othello's handkerchief, about which we are told in passing by Iago that it is "spotted with strawberries," while the hero himself reports that

> There's magic in the web of it.
> A sibyl that had numbered in the world
> The sun to course two hundred compasses
> In her prophetic fury sewed the work.
> The worms were hallowed that did breed the silk,
> And it was dyed in mummy, which the skilful
> Conserved of maidens' hearts. (3.4.67–73)

The second is a more literal ekphrasis. In *Cymbeline*, Iachimo, having wagered with Posthumus that he can seduce Imogen and failing to do so by persuasion, has himself delivered to her bedroom in a trunk, from which he exits, observes her sleeping, and is thus able to steal her bracelet and report on all he has seen of the heroine's intimate surroundings. As he watches, he declares, "I will write all down," referring to the pictures on the walls, the tapestry hangings on the bed, and, as he says, "the contents of the story"—though he doesn't tell us what they are. From this he goes on to the description of Imogen's body. We hear nothing more about the pictures in the room until two scenes later when Iachimo is making his report to Posthumus:

> First, her bedchamber—
> . . . it was hanged
> With tapestry of silk and silver; the story
> Proud Cleopatra, when she met her Roman.
> . . . a piece of work
> So bravely done, so rich, that it did strive
> In workmanship and value; which I wondered
> Could be so rarely and exactly wrought. . . .
> The chimney-piece
> Chaste Dian bathing. Never saw I figures
> So likely to report themselves; the cutter
> Was as another Nature; dumb, outwent her,
> Motion and breath left out. (2.4.66–84)

Finally one more rendering of a picture in words, from Edgar's speech to the blind Gloucester, who is contemplating suicide from the edge of a cliff that (unbeknownst to him) isn't really a cliff:

> How fearful
> And dizzy 'tis, to cast one's eyes so low!
> The crows and choughs that wing the midway air
> Show scarce so gross as beetles. Halfway down
> Hangs one that gathers sampire, dreadful trade!
> Methinks he seems no bigger than his head.
> The fishermen, that walk upon the beach,
> Appear like mice. . . .
> I'll look no more,
> Lest my brain turn, and the deficient sight
> Topple down headlong. (4.6.11–24)

Every one of these pictures is materially invisible to us. Depending on the design of the prop, we may glimpse the odd strawberry on the handkerchief, but there is no chance

for it to radiate all the mythic history Othello bestows on it. We *were* present with Iachimo in Imogen's bedroom, but the stage set is unlikely to have contained any of the narrative detail he shares with Posthumus. And as for Edgar's account of the Dover Cliff, we can't see it because it's not there. So in this Shakespearean art museum containing one piece of decorative art, one mythological *historia*, and one landscape, we have only the dramatic words to go by—that rhetorical *enargeia*, descriptions so vivid that they bring their subject before one's very eyes. This is the economy of the *paragone*, in which the desirability of the image fights to a draw with the attainability of the words. That Shakespeare is working his way beyond this balance is already clear from the fact that there is something dubious in all these transactions. Edgar's ekphrasis is a lie—which, I suppose, renders it the most impressive *enargeia* of all. Iachimo's is at the very least attached to a lie. And as for Othello, he is, after all, a notorious spinner of tales; and the handkerchief will become central to the performance of a lie (or two lies—one from Iago and the other from Desdemona).

More significant yet is the fact that these sets of pictures and words will gain their real significance from their place in a theatrical process. *Cymbeline's* audience sits in London watching a bare stage and hears a verbal description of classical pictures in words while, as a perfect complement, Posthumus sits in Rome and is treated to an ekphrastic rendering of the artwork decorating Imogen's bedroom back in Britain. In effect, Shakespeare is staging the drama of cultural absence and poetic recuperation in the spaces that separate picture from word and Italy from England. (It all begins with Posthumus's departure for Italy, which gets described quite precisely as his disappearance into a perspectival vanishing point.) Indeed, Shakespeare stages the whole play in the ekphrastic mode, as

images are shipped back and forth in fallible or mendacious words between Italy and England until only the dramatic device of twenty-five separate recognition scenes—themselves a play on what is spoken and what is seen—can resolve it all.

The handkerchief is also realized theatrically by becoming a moving, rather than a static, picture. In the end, what matters more than the iconic strawberries or the mythic sibyl is the sequence of dramatic placements of the object (rather like Poe's purloined letter): from Desdemona to Emilia to Iago to Cassio to Bianca, until it is shown up for the trifle it always was. And finally, the joke on Edgar's false ekphrasis is that it is indistinguishable from the Shakespearean means of creating theatrical illusion itself. As has been suggested, Edgar's imposture to his father could, without changing a word, serve for the dramatist to convince an audience that it is *really* on the edge of the Dover Cliff. Indeed, that is the joke on all these theatricalized ekphrases—that it is their theatrical force to inspire belief in a picture we cannot, or cannot quite, see.

Where there is nothing to see, the *poet* seeks to create ocular sense experience; where there is much to see, the *dramatist* wants to inspire faith in a picture that is invisible. It puts one in mind of another classic tale about the operations of art. Once again it involves Zeuxis: not his composite portrait of Helen, but, as we are told, a painting of grapes so real that it deceived the birds, who flew up to peck at them. As Pliny tells the story, Parrhasius, engaging in an artistic competition,

> produced such a realistic picture of a curtain that Zeuxis, proud of the verdict of the birds, requested that the curtain should now be drawn and the picture displayed. . . . When he realized his mistake . . . , he yielded up the prize, saying that whereas he had deceived birds Parrhasius had deceived him, an artist. (35.65)

The subject of the winning artwork is no accident. Zeuxis paints a visible picture, which is—dare I say?—for the birds, whereas Parrhasius paints an invisible picture, that is, the one Zeuxis imagines behind the curtain. What not everybody remembers about this often retold story is that it takes place in the theater. The grapes are part of a traditionally illusionistic stage front, but theirs is a simple pictorial imitation. The curtain, on the other hand, promises the much fuller, if less material, sense experience of complex theatrical mimesis, partly visible, partly imagined.

To conclude, then. Word and image, poetry and painting, language and visuality: these oppositions are the framework upon which artistic theory and practice have been stretched. The complete visual image or the complete visual representation or the complete metaphor is defined by the perfect integration of these contrasting terms. But the same integration is also a monstrosity. On which, once again, Shakespeare has anticipated us. When we last see the Poet and Painter in act 5 of *Timon*, they are being reviled by the angry hero, who describes the painter's art as "counterfeiting" and the poet's as "fiction." These two expressions are carefully chosen: they might appear as nonjudgmental, but in the corrupt context of Timon's world, they summon up all the potential falsehoods of representation.

More to the point, the terms *counterfeit* for the visual arts and *fiction* for the literary arts are not very different from each other. And that message, which is, after all, my own message in these pages, becomes the parting shot of Timon to this pair of creative sycophants, who seem perpetually to haunt him and each other. In effect, he tells the Poet and the Painter to separate, though it is not altogether clear from whom. Timon darkly warns that each of them is haunted by a deceitful knave whom they keep close to their bosom de-

spite his dishonesties and treacheries. How are we to take this accusation: are the Poet and Painter each other's deceitful knave, or does each of them act as his own built-in deceiver? All one can say for certain is, they leave as a pair. To borrow from elsewhere in Shakespeare: even when we insist that poetry and painting lie separately, it turns out that they lie together.

Afterword

I protest—just in case anyone should make the accusation—
that it was not by premeditation that I wrote a whole book
about word and image without ever using the words *Lessing* or
Laocoön, rather like producing a novel without the letter *e*. It
just happened that way, I insist. Upon reflection after the fact,
however, it strikes me as worthy of comment for two, possibly
contrasting, possibly parallel, reasons: First, because Lessing's
pronouncements on the subject, which focus on issues of tem-
porality, aesthetics, and the representation of reality, have be-
come so thoroughly assimilated to this topic that they seem
more like factual données than the brilliantly original theori-
zations that they actually are. And second, because I wanted
in my own way to get as far from them as possible. Consider
the remarkable jeu d'esprit with which he opens his essay. The
first person who compared poetry and painting, he tells us,
noticed that they produced similar sorts of pleasure: that was
the amateur. The second person noticed that both poetry and
painting derived from beauty, which could be analyzed in the

terms provided by aesthetics: that was the philosopher. The third person noticed that these aesthetic rules could be used to distinguish poetry and painting: that was the critic.

As my own foregoing pages demonstrate, I have no complaint against pleasure and beauty; on the other hand, it has been precisely my role as critic, *pace* Lessing, that has led me to raise some fundamental questions concerning that specially worthy enterprise which he stages as the climax of his tripartite division of labor, devoted to *distinguishing* poetry and painting. In that sense, this little volume of mine is the most respectful of countermeditations as regards the *Laocoön*. That work's subtitle, it should be remembered, is *An Essay on the Limits of Painting and Poetry*. Keeping in mind that enigmatic leave-taking of Timon's two sycophants, I'm just pushing Lessing's limits of painting and poetry a little further—not away from each other, but toward an inevitably ambiguous mutual embrace, which, like most embraces, maintains as much contradiction as it does unanimity.

On Sources and Further Readings

[N.B.: Names in **bold** refer to authors whose works can be found in the secondary bibliography. Quotations in the text are cited and referenced to the editions listed in the primary source bibliography.]

It has seemed appropriate, given the essayistic spirit of the present book, to forgo sequences of citation at each step of the argument. Instead, I offer here a discursive note—somewhere between briefly annotated bibliography and love letter to my favorite sources—so that readers may understand where I have been coming from and where they might go onward with the subject matters considered in these pages. A broader list of authors and titles, in traditional bibliographical format, follows.

General works in the field. As I have stated in the afterword, we all come to the word-and-image question breathing the air of **Lessing**'s *Laocoön*, the indispensable starting point for any consideration of the subject in modern times. Among the latter-day milestones, I would especially enumerate **Jean Hagstrum** and **Mario Praz**, the former for the meticulousness of

his literary and cultural analysis, the latter for the boldness—greater than mine—of its imaginative projections across the gap of different media.

So far as more recent work in the field is concerned, one might hazard a division of methodologies as among semiotics, iconology, and post-structuralism, granting that each of these categories embraces a wide variety of approaches. Among those whose work interested me for the way they connected word and image via the notion of *sign*, see especially **Mieke Bal** and **Norman Bryson**; but see also the challenges to this kind of connection offered by **James Elkins**. Iconology begins, of course, with **Erwin Panofsky** and flourishes in a whole descendancy of scholarly work to which I return below in the consideration of specifically Renaissance topics; but alongside Panofsky, one must cite the paradigm-establishing work of **Ernst Gombrich**, which stretches from the iconological (and therefore textual) operations of images all the way over into theories of seeing and theories of art. The post-structuralists—I cite the obvious names of **Roland Barthes**, **Jacques Derrida**, and **Michel Foucault**—do not often take up the word-image subject directly as a historical question, but, at least so far as the arguments in these pages are concerned, their deconstructive approach to the operations of language forms an essential basis for the way in which I analyze the semantic and hermeneutic workings of pictures and texts.

Then there are some theoretically informed scholars whose work cannot be so readily classified but without whom I could not have begun to think creatively about the topic in these pages. **Murray Krieger**'s work on ekphrasis (for additional citations on that topic, see below) goes far beyond the study of one trope toward a full theory of signification. **W.J.T. Mitchell** not only pioneered the word-image field as a fully theorized subject but also brought it into conversation with

all those forms of cultural critique that ground themselves in ideology. And **Harry Berger** has brilliantly applied his literary understanding of voice and viewership into a far-ranging set of meditations on pictorialism.

The classics. Throughout the forty-plus years of my scholarly career, it has been my experience as a Renaissance specialist that I have learned more from classicists than from anyone else (I've also learned more from the classics themselves—but that's another story), and the present subject is no exception. I cannot pay sufficient tribute to a whole generation of classicists—**Don Fowler, Simon Goldhill, Glenn Most, Daniel Selden, Froma Zeitlin**, *inter alia*—who have managed to be scholars, close readers, interdisciplinarians, and theorists all at once, and in graceful and lucid ways that somehow eluded many of us who have been working in post-antique fields. To which I would add a particular subset of individuals, similarly interdisciplinary, whose work on the Hellenistic period has demonstrated to me how all my favorite cultural forms seem to have had a flourishing in that epoch; I am thinking especially of **G. W. Bowersock, John Onians, J. J. Pollitt**, and **Andrew Stewart**.

But my purpose here is to focus on the word-image field. Three crucial concepts, all of them born in antiquity and fundamental to the operations of text and picture ever since, have sent me to school among the experts. On the subject of *skiagraphia*, I have learned from **Eva Keuls** and **Wesley Trimpi**. The range of approaches to *enargeia* can be viewed in the work of **Andrew Walker** and **Georg Zanker**, each of whom lays out the semantic field of the term itself; **Ann Vasaly**, who defines its relations to Roman rhetorical practice and theories of visuality; and **Andrew Feldherr**, who demonstrates how it functions in the writing of history and the operations of politics. All those authorities may be consulted as well on the third of

these terms: *ekphrasis*, which deserves a bibliographical essay unto itself. The classicists have spent quite a bit of time on the question of whether the object of ekphrastic description was necessarily a work of art; the correct answer is no, and yet many of us find it useful to focus on this special case, which has the *imprimatur* of the Shield of Achilles and many, many subsequent instances. **Shadi Bartsch** does lucid and valuable work of definition within this field; **Ruth Webb** takes a revealingly broad view of the subject, along with its relations to *enargeia* and *phantasia*; and **Page duBois** moves the topic fascinatingly toward issues about metaphor and questions of the inclusion and exclusion of viewing subjects in these implicit acts of observation. For a conspexus of ekphrasis as viewed by the best and the brightest in the twenty-first century, one can do no better than reading through the special issue of *Classical Philology* edited by **Shadi Bartsch** and **Jaś Elsner**.

And this would be a good moment to say that for all the classical subjects in this volume, I am a grateful reader above all of **Jaś Elsner**: his studies of ancient art objects, of their viewership, and of the languages they inspired are simply indispensable. Equally so, on another subject and from a different discipline, is the work of **Stephen Halliwell**. I would provide a bibliography of mimesis (surely the most important single concept in the present volume) twice as long as that for ekphrasis, were it not for the fact that he has done the scholarly and interpretive labor in so complete and inspiring a fashion. When I differ with him, I do so with trepidation: readers of his magisterial work who turn to my own speculations on similar subjects will recognize that I am less committed to a sense that Plato and Aristotle got it *right*—a difference that can be ascribed to the gap that separates a philosopher from a literary critic (or at least from *this* literary critic). I offer one final accolade for a classical volume that came to my attention

once most of the present book had been formulated: **Michael Squire** threads together brilliant readings of language and visuality in particular works of antiquity with a set of provocative theses concerning the theology and ideology of the image in the modern world.

The post-classics. The still useful spadework on the long afterlife of Horace's dictum about pictures and poems was done by **Rensselaer Lee**. At the other end of the methodology spectrum comes the profoundly inspiring work of **Michael Baxandall**, who has offered a complex but utterly lucid sense of the reciprocal operations between language and picture-making. Ekphrasis, once again, has been the object of subtle and informative scholarship, including the more theoretical interventions of the aforementioned **Krieger** and **Mitchell**, along with the indispensable art historical analyses by **Svetlana Alpers** and the eloquent poetical take on the matter by **John Hollander**. On the specifically English scene, where the subject of the visual does not seem to have quite the same options for interart comparison that can be exercised on the Continent, groundbreaking work to prove that there is a real subject here was done by **David Evett, Lucy Gent, Ernest Gilman**, and **Clark Hulse**. With what may have been narrower scholarly ambitions, the work of **R. A. Foakes** on visual representations of the English stage proved an absolute revelation.

Countless art historians of the Renaissance, whatever their specific subject matters or methodologies, have a great deal to say, explicitly or implicitly, about the relations of word and image. Some, like **Paola Barocchi, Paul Barolsky, Philip Sohm**, and **David Summers**, have devoted themselves (in quite different ways) to reading and analyzing the actual textual record of the visual arts. **Hubert Damisch, Michael Ann Holly,** and **Marilyn Lavin** have (again in different ways) analyzed the history of artistic practice in relation to discur-

sive matters like history, theory, and narrative. **Rona Goffen** and **Irving Lavin** are indispensable guides to many things, notably the multidimensional interrelations between pictures and the textual documents that surround them. About **David Rosand**, I can only say that wherever I choose to go, whether in the present volume or elsewhere—from Ovid to *ut pictura poesis* to ekphrasis to draughtsmanship—he has already been there and left a bright light burning to show me the way.

And finally, speaking of those who have long inspired me and whose work should count as primary materials for readers interested in further directions out of the present volume, I can cite with humility the entire project of the Warburg Institute, as intellectually vibrant now as it was in the beginning. I have already mentioned **Panofsky** and **Gombrich**. Others whose scholarship in the border territory of word and image include **Edgar Wind**, as acute in his pictorial readings of Platonism as he was concerning the whole transhistorical story of aesthetics; the undervalued **Fritz Saxl**, who possessed a truly original vision of what it meant in historical terms to understand an image as symbolic; **Frances Yates**, for her wholly original researches and theorizations of the intersections between text and image in the study of memory; and, of course, the eponymous **Aby Warburg**, whose interdisciplinary range—from the history of style to global aesthetics, from anthropology to the occult—continues to daunt any of us who imagine we know how to operate in more than one field.

Primary Sources: Works Consulted and Works Cited

Alberti, Leon Battista. *On Painting and on Sculpture*. Translated by
C. Grayson. London, 1972.
———. *On the Art of Building in Ten Books*. Translated by Joseph
Rykwert, Neil Leach, and Robert Tavernor. Cambridge, MA,
1988.
Aristotle. *Aristotle, with an English Translation: The "Art" of Rheto-
ric*. Translated by John Henry Freese. Loeb Classical Library.
London, 1926.
———. *The Metaphysics*. Translated by Hugh Tredennick and
G. Cyril Armstrong. Loeb Classical Library. London, 1933.
———. *Parts of Animals*. Translated by A. L. Peck and E. S. Forster.
Loeb Classical Library. Cambridge, MA, 1937.
———. *Poetics*. In Russell and Winterbottom, *Classical Literary
Criticism*.
———. *The Politics*. Translated by H. Rackham. Loeb Classical
Library. Cambridge, MA, 1932.
Armenini, Giovanni Battista. *On the True Precepts of the Art of
Painting*. Translated by Edward J. Olszewski. New York,
1977.

Athenaeus. *Deipnosophistae (The Learned Banqueters)*. Translated by S. Douglas Olson. Loeb Classical Library. Cambridge, MA, 2010.

Bacon, Francis. *The Advancement of Learning*. Edited by William Aldis Wright. Oxford, 1900.

Barthes, Roland. "Is Painting a Language?" In *The Responsibility of Forms: Critical Essays on Music, Art, and Representation*, translated by Richard Howard. New York, 1985.

Bodin, Jean. *Universae naturae theatrum*. Hanover, 1605.

Brink, Joel. *Simone Martini, Francesco Petrarca and the Humanistic Program of the Virgil Frontispiece*. Cambridge, 1977.

Cennini, Cennino. *Il libro dell'arte*. Edited by Mario Serchi. Florence, 1991.

Cervantes, Miguel. *Don Quixote*. Translated by Edith Grossman. New York, 2003.

Cicero. *De oratore*. Translated by E. W. Sutton and H. Rackham. Loeb Classical Library. Cambridge, MA, 1948.

———. *De inventione; De optimo genere oratorum; Topica*. Translated by H. M. Hubbell. Loeb Classical Library. Cambridge, MA, 1949.

Clement of Alexandria. "Exhortation to the Greeks." In *Clement of Alexandria*, translated by G. W. Butterworth. Loeb Classical Library. London, 1919.

Colonna, Francesco. *Hypnerotomachia Poliphili: The Strife of Love in a Dream*. Translated by Joscelyn Godwin. London, 1999.

Dante. *The Divine Comedy*. Translated by Charles S. Singleton. Princeton, NJ, 1980.

Dionysius of Halicarnassus. *The Critical Essays*. Translated by Stephen Usher. Loeb Classical Library. Cambridge, MA, 1974.

Dolce, Lodovico. "L'Aretino." In *Dolce's Aretino and Venetian Art Theory of the Cinquecento*, edited by Mark W. Roskill. New York, 1968.

———. "Letter." In *Raccolta di lettere sulla pittura, scultura ed architettura scritte da più celebri personaggi dei secoli XV, XVI*

e XVII, edited by G. Bottari and Stefano Ticozzi. Milan, 1822.

Erasmus. *The Correspondence of Erasmus*. Translated by R.A.B. Mynors, D.F.S. Thomson, and Wallace K. Ferguson. Toronto, 1974.

Freud, Sigmund. *The Standard Edition of the Complete Psychological Works of Sigmund Freud*. Translated by James Strachey. 24 vols. London, 1953–74.

Gregory the Great. "Letter to Serenus of Marseilles." In Celia Chazelle, "Pictures, Books and the Illiterate: Pope Gregory I's Letter to Serenus of Marseilles." *Word and Image* 6 (1990): 138–52.

Greek Anthology. Translated by W. R. Paton. Loeb Classical Library. Cambridge, MA, 1969.

Hollanda, Francisco de. *Four Dialogues on Painting*. Translated by Aubrey F. G. Bell. London, 1928.

Horace. "The Art of Poetry." In Russell and Winterbottom, *Classical Literary Criticism*.

———. *Epistles, Book II and Epistle to the Pisones (Ars poetica)*. Edited by Niall Rudd. Cambridge, 1989.

Leonardo da Vinci. *Leonardo on Painting: An Anthology of Writings*. Edited by Martin Kemp and Margaret Walker. New Haven, CT, 1989.

———. *Treatise on Painting*. Translated by A. Philip McMahon. Princeton, NJ, 1956.

Lessing, Gotthold Ephraim. *Laocoön: An Essay on the Limits of Painting and Poetry*. Translated by Edward Allen McCormick. Baltimore, 1984.

Montaigne, Michel de. *Complete Essays of Montaigne*. Translated by Donald M. Frame. Stanford, CA, 1958.

———. *Les Essais*. Edited by Jean Balsamo, M. Magnien, Catherine Magnien-Simonin, and Alain Legros. Paris, 2007.

Ovid. *Metamorphoses*. Translated by Frank Justus Miller. Loeb Classical Library. Cambridge, MA, 1964.

Petrarch. *Letters on Familiar Matters*. Translated by A. S. Bernardo. Albany, NY, 1975.

Petrarch. *Petrarch's Lyric Poems: The Rime Sparse and Other Lyrics.* Translated by Robert M. Durling. Cambridge, MA, 1976.

———. *Petrarch's Remedies for Fortune Fair and Foul: A Modern English Translation of De remediis utriusque fortune, with a Commentary.* Translated by Conrad H. Rawski. Bloomington, IN, 1991.

———. *Petrarch's Testament.* Edited and translated by Theodor Mommsen. Ithaca, NY, 1957.

———. *The Secret.* Edited by Carol E. Quillen. Boston, 2003.

———. *Trionfi; Rime estravaganti; Codice degli abbozzi.* Edited by Vinicio Pacca and Laura Paolino. Milan, 1996.

Philostratus and Callistratus. *Philostratus, Imagines; Callistratus, Descriptions.* Translated by Arthur Fairbanks. Loeb Classical Library. Cambridge, MA, 1931.

Pico della Mirandola, Giovanni Francesco. *Opera omnia.* Edited by Eugenio Garin. 2 vols. Turin, 1972.

Plato. *The Collected Dialogues of Plato, Including the Letters.* Edited by Edith Hamilton and Huntington Cairns. New York, 1961.

———. *The Republic.* In Russell and Winterbottom, *Classical Literary Criticism.*

Pliny. *Natural History.* Translated by Harris Rackham and D. E. Eichholz. Loeb Classical Library. Cambridge, MA, 1984.

Plutarch. "On the Fame of the Athenians." In *Plutarch's Moralia,* vol. 4, translated by Frank Cole Babbitt. Loeb Classical Library. Cambridge, MA, 1967.

Pseudo-Cicero. *Ad C. Herennium:. De ratione dicendi (Rhetorica ad Herennium).* Translated by Harry Caplan. Loeb Classical Library. Cambridge, MA, 1954.

Pseudo-Longinus. "On Sublimity." In Russell and Winterbottom, *Classical Literary Criticism.*

Pseudo-Lucian. *Erotes.* Translated by M. D. MacLeod. Loeb Classical Library. Cambridge, MA, 1967.

Quintilian. *The Instituto Oratoria of Quintilian.* Translated by Harold Edgeworth Butler. Loeb Classical Library. Cambridge, MA, 1921.

Raphael. In *Italian Art, 1500–1600: Sources and Documents*, edited by Robert Klein and Henri Zerner. Evanston, IL, 1989.

Russell, D. A., and Michael Winterbottom, eds. *Classical Literary Criticism*. Oxford, 1989.

Shakespeare, William. *The Norton Shakespeare*. Edited by Stephen Greenblatt, Walter Cohen, Jean E. Howard, and Katharine Eisaman Maus. New York, 1997.

Sidney, Sir Philip. *An Apology for Poetry*. Edited by Forrest G. Robinson. Indianapolis, IN, 1970.

Vasari, Giorgio. *Lives of the Painters, Sculptors, and Architects*. Translated by Gaston du C. De Vere. 2 vols. New York, 1996.

———. *Le opere di Giorgio Vasari*. Edited by Gaetano Milanesi. 9 vols. Florence, 1878–85.

Vives, Juan Luis. *De causis corruptarum artium*. Basel, 1555.

Vondel, Joost van. *De werken van Vondel*. Edited by J.F.M. Sterck. 11 vols. Amsterdam, 1927–37.

Further Readings *in Words and Images*

Alpers, Svetlana. *The Art of Describing: Dutch Art in the Seven-teenth Century*. Chicago, 1983.

————. "Ekphrasis and Aesthetic Attitudes in Vasari's *Lives*." *Journal of the Warburg and Courtauld Institutes* 23, nos. 3–4 (1960): 190–215.

Alpers, Svetlana, and Paul Alpers. "Ut pictura noesis? Criticism in Literary Studies and Art History." *New Literary History* 3, no. 3 (1972): 437–58.

Althusser, Louis. "Ideology and Ideological State Apparatuses: (Notes Towards an Investigation)." In *Lenin and Philosophy and Other Essays*, translated by Ben Brewster, 127–88. London, 1971.

Arnheim, Rudolf. "The Images of Pictures and Words." *Word and Image* 2, no. 4 (1986): 306–10.

————. *Visual Thinking*. Berkeley, CA, 1969.

Babbitt, Irving. *The New Laokoon: An Essay on the Confusion of the Arts*. Boston, 1910.

Bal, Mieke. *A Mieke Bal Reader*. Chicago, 2006.

Bal, Mieke. *Reading "Rembrandt": Beyond the Word-Image Opposition*. Cambridge, 1991.

Barchiesi, Alessandro. "Virgilian Narrative: Ecphrasis." In *The Cambridge Companion to Virgil*, edited by Charles Martindale, 271–81. Cambridge, 1997.

Barkan, Leonard. *The Gods Made Flesh: Metamorphosis and the Pursuit of Paganism*. New Haven, CT, 1986.

———. "Living Sculptures: Ovid, Michelangelo, and *The Winter's Tale*." *ELH* 48 (1981): 639–67.

———. "Making Pictures Speak: Italian Art, Elizabethan Literature, Modern Scholarship." *Renaissance Quarterly* 48 (1995): 326–51.

———. *Michelangelo: A Life on Paper*. Princeton, NJ, 2010.

———. *Transuming Passion: Ganymede and the Erotics of Humanism*. Stanford, CA, 1991.

Barocchi, Paola. *Scritti d'arte del cinquecento*. Milan, 1971.

———. *Trattati d'arte del cinquecento: Fra manierismo e controriforma*. Bari, 1960.

Barolsky, Paul. *Giotto's Father and the Family of Vasari's Lives*. University Park, PA, 1992.

———. *Why Mona Lisa Smiles and Other Tales by Vasari*. University Park, PA, 1991.

Barthes, Roland. *Camera Lucida: Reflections on Photography*. Translated by Richard Howard. New York, 1981.

———. *Image, Music, Text*. Translated by Stephen Heath. New York, 1978.

———. *S/Z*. Paris, 1970.

Bartsch, Shadi. *Decoding the Ancient Novel: The Reader and the Role of Description in Heliodorus and Achilles Tatius*. Princeton, NJ, 1989.

Bartsch, Shadi, and Jaś Elsner, eds. "Ekphrasis." Special issue, *Classical Philology* 102 (2007).

Baxandall, Michael. *Giotto and the Orators: Humanist Observers of Painting in Italy and the Discovery of Pictorial Composition, 1350–1450*. Oxford, 1971.

———. *Patterns of Intention: On the Historical Explanation of Pictures*. New Haven, CT, 1985.

Beall, Stephen M. "Word-Painting in the 'Imagines' of the Elder Philostratus." *Hermes* 121, no. 3 (1993): 350–63.

Berger, Harry. *Fictions of the Pose: Rembrandt against the Italian Renaissance*. Stanford, CA, 2000.

———. *Imaginary Audition: Shakespeare on Stage and Page*. Berkeley, CA, 1989.

———. *Second World and Green World: Studies in Renaissance Fiction-Making*. Berkeley, CA, 1988.

Berger, John. *Ways of Seeing*. London, 1972.

Bettini, Maurizio. *The Portrait of the Lover*. Translated by Laura Gibbs. Berkeley, CA, 1999.

———. "Tra Plinio e sant'Agostino: Francesco Petrarca sulle arti figurative." In *Memoria dell'antico nell'arte italiana*, edited by Salvatore Settis, 222–67. Turin, 1984.

Bowersock, Glen W. *Hellenism in Late Antiquity*. Ann Arbor, MI, 1990.

Braider, Christopher. *Refiguring the Real: Picture and Modernity in Word and Image, 1400–1700*. Princeton, NJ, 1993.

Brieger, Peter H., Millard Meiss, and Charles Southward Singleton. *Illuminated Manuscripts of the Divine Comedy*. Princeton, NJ, 1969.

Bryson, Norman. *Vision and Painting: The Logic of the Gaze*. New Haven, CT, 1983.

———. *Word and Image: French Painting of the Ancien Régime*. Cambridge, 1981.

Bryson, Norman, Michael Ann Holly, and Keith P. F. Moxey. *Visual Theory: Painting and Interpretation*. Cambridge, 1991.

Burwick, Frederick. "Lessing's 'Laokoon' and the Rise of Visual Hermeneutics." *Poetics Today* 20, no. 2 (1999): 219–72.

Chazal, Roger, and Gisèle Mathieu-Castellani, eds. *La pensée de l'image: Signification et figuration dans le texte et dans la peinture*. Paris, 1994.

Clements, Robert J. "The Identity of Literary and Artistic Theory in the Renaissance." Chap. 1 in *The Peregrine Muse: Studies in Comparative Renaissance Literature*, 1–26. Chapel Hill, NC, 1959.

———. *Michelangelo's Theory of Art*. New York, 1961.

Conte, Gian Biagio. *The Rhetoric of Imitation: Genre and Poetic Memory in Virgil and Other Latin Poets*. Translated by Charles P. Segal. Ithaca, NY, 1986.

Curtius, Ernst Robert. *European Literature and the Latin Middle Ages*. Translated by Willard R. Trask. Bollingen Series. Princeton, NJ, 1973.

Damisch, Hubert. *The Origin of Perspective*. Translated by John Goodman. Cambridge, MA, 1994.

De Armas, Frederick A. *Quixotic Frescoes: Cervantes and Italian Renaissance Art*. Toronto, 2006.

Derrida, Jacques. *La vérité en peinture*. Paris, 1978.

Doebler, John. "Bibliography for the Study of Iconography and Renaissance English Literature." *Research Opportunities in Renaissance Drama* 22 (1979): 45–55.

———. *Shakespeare's Speaking Pictures: Studies in Iconic Imagery*. Albuquerque, NM, 1974.

Dolders, Arno. "Ut pictura poesis: A Selective Annotated Bibliography of Books and Articles, Published between 1900 and 1980, on the Interrelation of Literature and Painting between 1400 and 1800." *Yearbook of Comparative and General Literature* 32 (1983): 105–24.

Dubel, Sandrine. "Ekphrasis et enargeia: Le description antique comme parcours." In *Dire l'évidence: Philosophie et rhétorique antiques*, edited by Carlos Lévy and Laurent Pernot, 249–64. Paris, 1997.

DuBois, Page. *History, Rhetorical Description and the Epic from Homer to Spenser*. Cambridge, 1982.

Elkins, James. *The Domain of Images*. Ithaca, NY, 1999.

———. *On Pictures and the Words That Fail Them*. Cambridge, 1998.

———. *The Poetics of Perspective*. Ithaca, NY, 1994.

Elsner, Jaś. *Art and the Roman Viewer*. Cambridge Studies in New Art History and Criticism. Cambridge, 1995.

———. "Introduction: The Genres of Ekphrasis." *Ramus* 31 (2002): 1–18.

———. *Roman Eyes: Visuality and Subjectivity in Art and Text*. Princeton, NJ, 2007.

———. "Seeing and Saying: A Psycho-Analytic Account of Ekphrasis." *Helios* 31 (2004): 153–80.

———, ed. "The Verbal and the Visual: Cultures of Ekphrasis in Antiquity." Special issue, *Ramus* 31 (2002).

———. "Visual Mimesis and the Myth of the Real: Ovid's Pygmalion as Viewer." *Ramus* 20 (1995): 154–69.

Emmens, Jan A. "Apelles en Apollo: Nederlandse gedichten op schilderijen in de 17e eeuw." Chap. 1 in *Kunsthistorische opstellen: Verzameld werk / J. A. Emmens*, 5–60. Amsterdam, 1981.

Evett, David. *Literature and the Visual Arts in Tudor England*. Athens, GA, 1990.

Fairchild, Arthur H. R. *Shakespeare and the Arts of Design: Architecture, Sculpture, and Painting*. Columbia, MO, 1937.

Feldherr, Andrew. *Spectacle and Society in Livy's History*. Berkeley, CA, 1998.

Ferretti, Silvia. *Cassirer, Panofsky, and Warburg: Symbol, Art, and History*. Translated by Richard Pierce. New Haven, CT, 1989.

Foakes, Reginald A. *Illustrations of the English Stage, 1580–1642*. Stanford, CA, 1985.

Foucault, Michel. *The Order of Things: An Archaeology of the Human Sciences*. New York, 1970.

———. *This Is Not a Pipe*. Translated by James Harkness. Berkeley, CA, 1973.

Fowler, Don P. "Even Better Than the Real Thing: A Tale of Two Cities." In *Art and Text in Roman Culture*, edited by Jaś Elsner, 54–74. Cambridge Studies in New Art History and Criticism. Cambridge, 1996.

Fowler, Don P. "Narrate and Describe: The Problem of Ekphrasis." *Journal of Roman Studies* 81 (1991): 25–35.

Gent, Lucy. *Picture and Poetry 1560–1620: Relations between Literature and the Visual Arts in the English Renaissance.* Leamington Spa, UK, 1981.

Gilbert, Creighton. *Poets Seeing Artists' Work: Instances in the Italian Renaissance.* Florence, 1991.

Gilman, Ernest B. *The Curious Perspective: Literary and Pictorial Wit in the Seventeenth Century.* New Haven, CT, 1978.

Goffen, Rona. *Renaissance Rivals: Michelangelo, Leonardo, Raphael, Titian.* New Haven, CT, 2002.

Goldhill, Simon. "The Naive and Knowing Eye: Ecphrasis and the Culture of Viewing in the Hellenistic World." In *Art and Text in Ancient Greek Culture*, edited by Simon Goldhill and Robin Osborne, 197–223.

Goldhill, Simon, and Robin Osborne, eds. *Art and Text in Ancient Greek Culture.* Cambridge Studies in New Art History and Criticism. Cambridge, 1993.

Gombrich, Ernst H. *Aby Warburg: An Intellectual Biography.* London, 1970; 2nd ed., 1986.

———. *Art and Illusion: A Study in the Psychology of Pictorial Representation.* London, 1968.

———. "Image and Word in Twentieth Century Art." *Word and Image* 1, no. 3 (1985): 213–41.

———. *Norm and Form: Studies in the Art of the Renaissance I.* Oxford, 1978.

———. *Symbolic Images: Studies in the Art of the Renaissance.* London, 1972.

Goodman, Nelson. *Languages of Art: An Approach to a Theory of Symbols.* Indianapolis, IN, 1968.

Gordon, D. J. *The Renaissance Imagination: Essays and Lectures,* edited by Stephen Orgel. Berkeley, CA, 1975.

Graf, Fritz. "Ekphrasis: Die Entstehung der Gattung in der Antike." In *Beschreibungskunst—Kunstbeschreibung: Ekphrasis von der*

Antike bis zur Gegenwart, edited by Gottfried Boehm and
 Helmut Pfotenhauer, 141–55. Munich, 1995.

Guillén, Claudio. "On the Concept and Metaphor of Perspective."
 In *Comparatists at Work: Studies in Comparative Literature*,
 edited by Stephen G. Nichols and Richard Vowles, 28–90.
 Waltham, MA, 1968.

Hagstrum, Jean H. *The Sister Arts: The Tradition of Literary Pictori-
 alism and English Poetry from Dryden to Gray*. Chicago, 1958.

Halliwell, Stephen. *The Aesthetics of Mimesis: Ancient Texts and
 Modern Problems*. Princeton, NJ, 2002.

Heckscher, W. S. "Shakespeare and His Relationship to the Visual
 Arts: A Study in Paradox." *Research Opportunities in Renais-
 sance Drama* 13, no. 4 (1970–71): 5–71.

Heffernan, James A. W. "Ekphrasis and Representation." *New Lit-
 erary History* 22, no. 2 (1991): 297–316.

———. *Museum of Words: The Poetics of Ekphrasis from Homer to
 Ashbery*. Chicago, 1993.

Heninger, S. K., Jr. "Sidney's Speaking Pictures and the Theater."
 Style 23 (1989): 395–404.

Hollander, John. *The Gazer's Spirit: Poems Speaking to Silent Works
 of Art*. Chicago, 1995.

———. "The Poetics of Ekphrasis." *Word and Image* 4 (1988):
 209–19.

Holly, Michael Ann. *Panofsky and the Foundations of Art History*.
 Ithaca, NY, 1984.

———. *Past Looking: Historical Imagination and the Rhetoric of the
 Image*. Ithaca, NY, 1996.

Hulse, Clark. *The Rule of Art: Literature and Painting in the
 Renaissance*. Chicago, 1990.

Hunt, John Dixon. *Encounters: Essays on Literature and the Visual
 Arts*. London, 1971.

Jay, Martin. *Downcast Eyes: The Denigration of Vision in Twentieth-
 Century French Thought*. Berkeley, CA, 1993.

Keuls, Eva. *Plato and Greek Painting*. Leiden, 1978.

Keuls, Eva. "Skiagraphia Once Again." *American Journal of Archae-ology* 79, no. 1 (1975): 1–16.

Koortbojian, Michael. *Myth, Meaning, and Memory on Roman Sarcophagi*. Berkeley, CA, 1995.

Krieger, Murray. "Ekphrasis and the Still Movement of Modern Poetry: Or Laokoön Revisited." In *The Poet as Critic: Essays*, edited by Frederick P. W. McDowell, 3–26. Evanston, IL, 1967.

———. *Ekphrasis: The Illusion of the Natural Sign*. Baltimore, 1992.

Kristeller, Paul Oskar. "The Modern System of the Arts: A Study in the History of Aesthetics Part I." *Journal of the History of Ideas* 12, no. 4 (1951): 496–527.

———. "The Modern System of the Arts: A Study in the History of Aesthetics (II)." *Journal of the History of Ideas* 13, no. 1 (1952): 17–46.

Laird, Andrew. "Sounding Out Ecphrasis: Art and Text in Catullus 64." *Journal of Roman Studies* 83 (1993): 18–30.

———. "*Ut figura poesis*: Writing Art and the Art of Writing in Augustan Poetry." In *Art and Text in Roman Culture*, edited by Jaś Elsner, 75–102. Cambridge Studies in New Art History and Criticism. Cambridge, 1996.

Lavin, Irving. "Divine Inspiration in Caravaggio's Two St. Matthews." *Art Bulletin* 56, no. 1 (1974): 59–81.

———. *Past-Present: Essays on Historicism in Art from Donatello to Picasso*. Berkeley, CA, 1993.

Lavin, Marilyn Aronberg. *The Place of Narrative: Mural Decoration in Italian Churches, 431–1600*. Chicago, 1990.

Leach, Eleanor. "*Ekphrasis* and the Theme of Artistic Failure in Ovid's *Metamorphoses*." *Ramus* 3 (1974): 102–42.

———. "Narrative Space and the Viewer in Philostratus' *Eikones*." *Mitteilungen des Deutschen Archaeologischen Instituts Römische Abteilung* 107 (2000): 237–52.

Lee, Rensselaer W. *Names on Trees: Ariosto into Art*. Princeton, NJ, 1977.

———. *Ut pictura poesis: The Humanistic Theory of Painting*. New York, 1967.

Lesky, Albin. "Bildwerk und Deutung bei Philostrat und Homer." *Hermes* 75, no. 1 (1940): 38–53.

Lipking, Lawrence I. *The Ordering of the Arts in Eighteenth-Century England*. Princeton, NJ, 1970.

"Literary and Art History." Special issue, *New Literary History* 3, no. 3 (1972).

Mansfield, Elizabeth. *Too Beautiful to Picture: Zeuxis, Myth, and Mimesis*. Minneapolis, 2007.

Marek, Michaela J. *Ekphrasis und Herrscherallegorie: Antike Bildbeschreibungen im Werk Tizians und Leonardos*. Worms, 1985.

Marin, Louis. *Sublime Poussin*. Translated by Catherine Porter. Stanford, CA, 1999.

———. *To Destroy Painting*. Translated by Mette Hjort. Chicago, 1995.

McCormick, E. Allen. "Poema pictura loquens: Literary Pictorialism and the Psychology of Landscape." *Comparative Literature Studies* 13, no. 3 (1976): 196–213.

Mendelsohn, Leatrice. *Paragoni: Benedetto Varachi's Due lezzioni and Cinquecento Art Theory*. Ann Arbor, MI, 1981.

Miller, J. Hillis. "What Do Stories about Pictures Want?" Special supplemental issue for W.J.T. Mitchell, *Critical Inquiry* 34, no. 5 (2008): 59–97.

Mitchell, W.J.T. "Ekphrasis and the Other." *South Atlantic Quarterly* 91 (1992): 695–719.

———. *Iconology: Image, Text, Ideology*. Chicago, 1986.

———. *The Language of Images*. Chicago, 1980.

———. *Picture Theory: Essays on Verbal and Visual Representation*. Chicago, 1994.

———. *What Do Pictures Want?: The Lives and Loves of Images*. Chicago, 2005.

Most, Glenn W. *Raffael: Die Schule von Athen; Über das Lesen der Bilder*. Frankfurt, 1998.

Mulvey, Laura. *Visual and Other Pleasures*. Bloomington, IN, 1989.

Newman, Sara. "Aristotle's Notion of 'Bringing-before-the-Eyes': Its Contributions to Aristotelian and Contemporary Conceptualizations of Metaphor, Style, and Audience." *Rhetorica: A Journal of the History of Rhetoric* 20, no. 1 (2002): 1–23.

Nuttall, Anthony D. *Why Does Tragedy Give Pleasure?* Oxford, 1996.

Onians, John. *Art and Thought in the Hellenistic Age: The Greek World View, 350–50 BC*. London, 1979.

Orgel, Stephen. *The Illusion of Power: Political Theater in the English Renaissance*. Berkeley, CA, 1975.

Orgel, Stephen, and Roy C. Strong. *The Theatre of the Stuart Court: Including the Complete Designs for Productions at Court, for the Most Part in the Collection of the Duke of Devonshire, Together with Their Texts and Historical Documentation*. London, 1973.

Panofsky, Erwin. *Idea: A Concept in Art Theory*. Translated by Joseph J. S. Peake. Columbia, SC, 1968.

———. *Meaning in the Visual Arts: Papers in and on Art History*. Garden City, NY, 1955.

———. *Perspective as Symbolic Form*. Translated by Christopher S. Wood. New York, 1991.

———. *Studies in Iconology: Humanistic Themes in the Art of the Renaissance*. New York, 1939.

Panofsky, Erwin, and Fritz Saxl. "Classical Mythology in Mediaeval Art." *Metropolitan Museum Studies* 4, no. 2 (1933): 228–80.

Paulson, Ronald. *Book and Painting: Shakespeare, Milton, and the Bible*. Knoxville, TN, 1982.

Perutelli, Alessandro. "L'inversione speculare: Per una retorica dell'ekphrasis." *Materiali e Discussioni per l'Analisi dei Testi Classici* 1 (1978): 87–98.

Pollitt, Jerome J. *Art in the Hellenistic Age*. Cambridge, 1986.

———. "The Canon of Polykleitos and Other Canons." In *Polykleitos, the Doryphoros, and Tradition*, edited by Warren G. Moon, 19–24. Madison, WI, 1995.

Praz, Mario. *Mnemosyne: The Parallel between Literature and the Visual Arts*. Princeton, NJ, 1970.

Price-Zimmerman, T. C. "Paolo Giovio and the Evolution of Renaissance Art Criticism." In *Cultural Aspects of the Italian Renaissance: Essays in Honour of Paul Oskar Kristeller*, edited by Cecil H. Clough, 406–24. Manchester, UK, 1976.

Rancière, Jacques. "The Body of the Letter: Bible, Epic, Novel." Sec. 2, chap. 1 in *The Flesh of Words: The Politics of Writing*, translated by Charlotte Mandell, 71–94. Stanford, CA, 2004.

———. *The Future of the Image*. Translated by Gregory Elliott. London, 2007.

———. *The Politics of Aesthetics: The Distribution of the Sensible*. Translated by Gabriel Rockhill. London, 2006.

———. "The Space of Words: From Mallarmé to Broodthaers." In *Porous Boundaries: Texts and Images in Twentieth-Century French Culture*, edited by Jérôme Game, 41–61. Oxford, 2007.

"Renaissance Art and Literature." Special issue, *Word and Image* 3, no. 1 (1987).

Riffaterre, Michael. "L'illusion d'ekphrasis." In *La pensée de l'image: Signification et figuration dans le texte et dans la peinture*, edited by Roger Chazal and Gisèle Mathieu-Castellani, 211–29. Paris, 1994.

Rosand, David. *Drawing Acts: Studies in Graphic Expression and Representation*. Cambridge, 2002.

———. " 'Troyes Painted Woes': Shakespeare and the Pictorial Imagination." *Hebrew University Studies in Literature and the Arts* 8 (1980): 77–97.

———. "Ut pictor poeta: Meaning in Titian's *Poesie*." *New Literary History* 3 (1972): 527–46.

Roskill, Mark W. *Dolce's* Aretino *and Venetian Art Theory of the Cinquecento*. New York, 1968.

Roston, Murray. *Renaissance Perspectives in Literature and the Visual Arts*. Princeton, NJ, 1987.

Saxl, Fritz. *Lectures*. 2 vols. London, 1957.

Scharpling, Gerard Paul. *The Role of the Image in the Prose Writing of Erasmus, Rabelais, Marguerite De Navarre and Montaigne*. Lewiston, UK, 2003.

———. "Towards a Rhetoric of Experience: The Role of Enargeia in the Essays of Montaigne." *Rhetorica* 10, no. 2 (2002): 173–92.

Schlosser, Julius, and Otto Kurz. *La letteratura artistica: Manuale delle fonti della storia dell'arte moderna*. Florence, 1977.

Schlueter, June. "Re-Reading the Peacham Drawing." *Shakespeare Quarterly* 50, no. 2 (1999): 171–84.

Small, Jocelyn Penny. *The Parallel Worlds of Classical Art and Text*. Cambridge, 2003.

Sohm, Philip L. *Style in the Art Theory of Early Modern Italy*. Cambridge, 2001.

Soussloff, Catherine M. "Lives of Poets and Painters in the Renaissance." *Word and Image* 6 (1990): 154–62.

———. "The Trouble with Painting, the Image (Less) Text." *Journal of Visual Culture* 4, no. 2 (2005): 203–36.

Sparrow, John. *Visible Words: A Study of Inscriptions in and as Books and Works of Art*. London, 1969.

Spencer, John R. "Ut rhetorica pictura: A Study in Quattrocento Theory of Painting." *Journal of the Warburg and Courtauld Institutes* 20 (1957): 26–44.

Spitz, Ellen Handler. "Picturing the Child's Inner World of Fantasy: On the Dialectic between Image and Word." *Psychoanalytic Study of the Child* 43 (1988): 433–47.

Squire, Michael. *Image and Text in Graeco-Roman Antiquity*. Cambridge, 2009.

Steiner, Wendy. *The Colors of Rhetoric: Problems in the Relation between Modern Literature and Painting*. Chicago, 1982.

———. *Pictures of Romance: Form against Context in Painting and Literature*. Chicago, 1988.

Stewart, Andrew F. *Art, Desire and the Body in Ancient Greece*. Cambridge, 1997.

————. *Greek Sculpture: An Exploration*. New Haven, CT, 1990.

Summers, David. *Michelangelo and the Language of Art*. Princeton, NJ, 1981.

Sypher, Wylie. *Four Stages of Renaissance Style: Transformations in Art and Literature, 1400–1700*. Garden City, NY, 1955.

Trimpi, Wesley. "The Early Metaphorical Uses of ΣΚΙΑΓΡΑΦΙΑ and ΣΚΗΝΟΓΡΑΦΙΑ." *Traditio* 34 (1978): 403–13.

————. "The Meaning of Horace's ut pictura poesis." *Journal of the Warburg and Courtauld Institutes* 36 (1973): 1–34.

Vasaly, Ann. *Representations: Images of the World in Ciceronian Oratory*. Berkeley, CA, 1993.

Waage, Frederick O. "Be Stone No More: Italian Cinquecento Art and Shakespeare's Last Plays." *Bucknell Review* 25 (1980): 56–90.

Walker, Andrew D. "Enargeia and the Spectator in Greek Historiography." *Transactions of the American Philological Association* 123 (1993): 353–77.

Webb, Ruth. "Ekphrasis Ancient and Modern: The Invention of a Genre." *Word and Image* 15 (1999): 7–18.

————. "Mémoire et imagination: Les limites de *l'enargeia* dans la théorie rhétorique grecque." In *Dire l'évidence: Philosophie et rhétorique antiques*, edited by Carlos Lévy and Laurent Pernot, 112–27. Paris, 1997.

————. "Picturing the Past: Uses of Ekphrasis in the *Deipnosophistae*." In *Athenaeus and His World: Reading Greek Culture in the Roman Empire*, edited by David Braund and John Wilkins, 218–26. Exeter, UK, 2000.

Wellek, René. "The Parallelism between Literature and the Arts." *English Institute Annual, 1941* (1942): 29–63.

West, William N. *Theaters and Encyclopedias in Early Modern Europe*. Cambridge, 2006.

Whitmarsh, Tim. "Written on the Body: Ecphrasis, Perception and Deception in Heliodorus' *Aethiopica*." *Ramus* 31 (2002): 111–25.

Wind, Edgar. *The Eloquence of Symbols*. Oxford, 1993.

Wind, Edgar. *Pagan Mysteries in the Renaissance*. New Haven, CT, 1958; rev. ed., 1968.

Wittkower, Rudolf. *Allegory and the Migration of Symbols*. London, 1977.

Yates, Frances A. *The Art of Memory*. Chicago, 1966.

———. *Theatre of the World*. London, 1969.

Zanker, Graham. "Enargeia in Ancient Criticism of Poetry." *Rheinisches Museum für Philologie* 124 (1981): 297–311.

Zeitlin, Froma. "The Artful Eye: Vision, Ekphrasis and Spectacle in the Euripidean Theater." In *Art and Text in Ancient Greek Culture*, edited by Simon Goldhill and Robin Osborne, 138–96.

Index

The index below refers to the body of the text. Scholarly works referenced in "On Sources and Further Readings" can be found in the bibliographies.